How to Paint
PORTRAITS FROM
PHOTOGRAPHS

How to Paint PORTRAITS FROM PHOTOGRAPHS

Johan du Toit

Watson-Guptill Publications/New York

Copyright © 1992 Johan du Toit

First published in 1992 in the United States by Watson-Guptill Publications,
a division of BPI Communications, Inc.,
1515 Broadway, New York, N.Y. 10036.

Library of Congress Cataloging-in-Publication Data

du Toit, Johan.
 How to paint portraits from photographs / Johan du Toit.
 p. cm.
 Includes index.
 ISBN 0-8230-2457-1
 1. Portrait painting—Technique. 2. Painting from photographs.
 I. Title.
 ND1302.D8 1992 92-12190
 751.45'42—dc20 CIP

Distributed in Europe, the Far East, Southeast and Central Asia, and South America
by RotoVision S.A., 9 Route Suisse, CH-1295 Mies, Switzerland.

Manufactured in Singapore

First printing, 1992

1 2 3 4 5 6 7 8 9 10 / 96 95 94 93 92

Senior Editor: Candace Raney
Associate Editor: Janet Frick
Designer: Jay Anning
Graphic Production: Ellen Greene
Text set in Century Old Style

I dedicate this book to my wife, who gives me inspiration to keep on;

to my mother, who has always been there;

to my stepfather, who made it possible for me to come to America;

and to the memory of my sister, father, aunt, and grandparents, who were authors in their own right.

The demonstration in Skill Level One was made possible through the gracious consent of Mr. and Mrs. D'Luzio of Atlanta, Georgia, to have their young son's portrait appear in the pages of this book.

I am also grateful to Mrs. Kathleen McGuire Brooks; to The Honorable A. W. Birdsong, Jr., Presiding Judge, Georgia Court of Appeals; and to Mr. and Mrs. R. C. Clemons, who have kindly consented to be portrayed here.

Contents

SETTING UP FOR PORTRAIT PAINTING

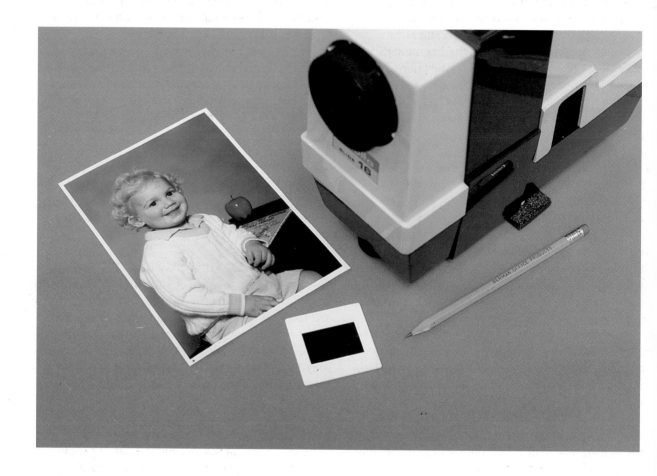

Beautiful Portraits Every Time

This book will show you how to paint a portrait with a true likeness to an original photograph, in which both form and complexion are rendered in a realistic style. To accomplish this, you will need to follow a disciplined method, especially at first. As you progress through the book, you will find that this general painting method is adaptable to various levels of skill; more advanced painters can take "shortcuts" while still applying the same general principles explained at the beginning.

In developing the method described here, I began by reducing the mysterious into simple terms that promise predictable results. Following these guidelines will enable you to tap the full potential of oils—the medium that countless masters of portrait painting have used for centuries.

Every painter must choose materials, prepare them, plan a strategy for approaching the canvas, mix paint, load a brush, stroke paint onto the canvas, blend each stroke with others, and then correct errors before reloading the brush. These eight seemingly mundane and repetitive actions are the source of any painter's stumbling blocks—or of reliable success. By isolating what works well and learning to repeat it, you can learn to master an approach to portraiture that will work every time.

The eight substeps just mentioned are introduced here in an abstract form and then examined in detail in the following pages. The last five of these—mixing, loading the brush, stroking on the paint, blending, and cleaning up—are repeated many times during the course of every portrait. They are of paramount importance if you are to learn my basic four-color method of painting. Once you have learned it, but not until then, you are encouraged to adjust them to suite your taste and style of painting.

CHOOSING MATERIALS AND SUPPLIES

As you become a better painter and temporarily press the outer limits of your skill, the natural process is also to press the outer limits of your painting tools. For this reason you should be willing to examine them from time to time in case there is room for improvement. My own choice of materials is based on my experience in using them; I have often discarded one type or brand in favor of another.

Some artists prefer to stretch their own canvases. I use store-bought canvases for most of my work because they are convenient, readily available, and usually of good quality. Although they come prestretched and primed, they are usually not tight enough or smooth enough for my purposes and require modification.

I prefer synthetic soft brushes because they are cheaper than sable and actually softer. They also keep their hair longer. Do not buy bristle brushes for realistic portraiture; they are not meant for blending smooth surfaces.

SETTING UP YOUR STUDIO

Give some thought to the area you paint in: the room, the easel, the lighting. Place your palette, canvas, and original photograph so that you will be comfortable and can see everything easily during the painting process.

CHOOSING A PHOTO OF YOUR SUBJECT

The photograph you pick of your subject should be of studio quality. That is, it should have good color and sharp focus—characteristics often missing in snapshots. School pictures are common examples of quality photographs. A photograph that is roughly 1/4 to 1/2 the size of the canvas is ideal, but this is not always possible.

DRAWING A LIKENESS ON THE CANVAS

The daunting prospect of drawing a freehand likeness on the canvas discourages many people from progressing in portrait painting or even mustering the confidence to try. We will overcome this obstacle for the purpose of instruction in this book by using a slide projector and a 35mm slide copy of the original photograph, so that we can draw an outline of the subject from an image projected onto the canvas. Some artists prefer to use an opaque projector, in which a slide copy is not necessary because the image is taken directly off the original photograph. This straightforward method is not covered in this book, but use it by all means if you like it better.

DIVIDING A PORTRAIT INTO WORK AREAS

Every portrait has five work areas, and you will learn how to render them in Skill Level One. Later in this book you will learn more advanced approaches to try once you become proficient. I do recommend that you be patient enough to master Skill Level One first, since so much can go wrong in the pursuit of a true likeness.

MIXING COLORS

Every work area is begun at its darkest point as indicated by the original photograph. You will mix a matching tone and adjust it gradually lighter until this work area is finished. The next work area is also begun at its darkest point but not necessarily with the same color. The mixing exercise on pages 22–23 will introduce you to the mixed tones on which all complexions are based. I encourage you to repeat this exercise often.

The mixing exercise shows how we can start out with only four basic oil colors—blue, red, yellow, and white—and develop all the mixed tones ever needed for painting portraits realistically.

LOADING THE BRUSH

We use three brushes to paint the face and a fourth brush to paint the background. The first two are no. 1 and no. 3 (1/16 and 1/8 inch wide) round brushes used in detailed areas along pencil lines of the drawing and for use in confined areas. As needed their hair can be shaped either pointed, flat, or fanned during loading of mixed tone onto the brush. The no. 6 flat brush is used to blend larger areas of the face, such as the cheeks and forehead, and the no. 12 flat brush is used for painting the background.

STROKING ON THE PAINT

Stroking paint onto to the canvas in a specific location is the forerunner of blending. Stroking is the physical transfer of brushloads of mixed paint from the palette to the canvas. Generally a stroke's path follows details observed in the photograph along their representative pencil lines on the canvas.

Some sophisticated stroking is required when rendering hair, where particular consideration is given to a stroke's beginning, middle, and ending as the brush lifts off the canvas.

But beyond this, during extended brush action, stroking quickly becomes blending where the difference is more a matter of a shift in mind focus than a change in brush handling—a shift away from simply covering canvas to sophisticated guidance instead of tones flowing together in the wake.

BLENDING

While stroking is considered the initial application of tones into a work area on canvas, successful blending goes beyond the simple dispersion of tone to where different tones flow together under your control into a masterful rendition of realistic shape and complexion. Certainly some dexterity is called for with an adequate degree of eye-hand coordination but successful blending can be learned and only perfected with practice.

CLEANING UP

It is necessary to remove brush marks and correct any errors before reloading the brush. This is particularly true if you are about to change tone, or when you have completed one work area and are about to begin another. In addition to the photograph, you will be relying heavily on previously completed work for guidance, so any errors you leave on the canvas will only cause confusion later.

These basic substeps will guide you toward painting an exact likeness with natural tones. You will learn to become a keen observer of form and color, and to convey what you see on the canvas.

Materials and Supplies

There are certain materials you will need before you can begin painting a portrait. Here is a shopping list for your convenience:

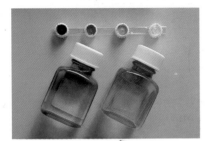

OIL PAINTS AND MEDIUMS

French ultramarine.

Cadmium red deep.

Cadmium yellow medium.

Titanium white.

Linseed oil, for thinning paint when painting hair.

Odorless thinner, for removing excess graphite from the canvas and for cleaning brushes before storage.

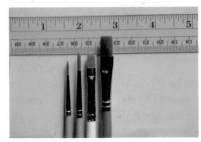

BRUSHES (ALL WITH SYNTHETIC SOFT HAIR)

No. 1 (1/16") round liner.

No. 3 (1/8") round liner.

No. 6 (1/4") flat.

No. 12 (1/2") flat.

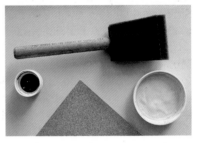

CANVAS AND RELATED MATERIALS

Store-bought canvas, 11 x 14", prestretched and primed.

Sandpaper, to make the canvas surface smoother.

Gesso, a primer to recoat the surface after each sanding.

Sponge brush, a stick with a sponge to apply the primer.

Black acrylic, water-based paint to tint the gesso gray.

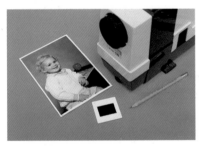

TOOLS FOR DRAWING ON THE CANVAS

5 x 7" or 8 x 10" studio-quality photo.

35mm slide copy of the original photo.

Projector for 35mm slides.

No. 2 pencil for outlining your subject on canvas.

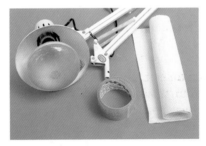

SUPPLIES FOR SETTING UP YOUR STUDIO

Table-top or stand-alone easel to hold the canvas.

2 clamp-on, swivel-arm lamps, rated 100W each, with ceramic sockets to resist heat.

2 spotlight bulbs, rated 100W each.

Paper towels for wiping brushes during painting.

Transparent package tape, 3" wide, used as a palette.

Setting Up Your Studio

Attach the lamps to the easel on the side opposite your drawing hand, so that its shadow falls out of the way. I recommend either daylight-balanced artist's spotlights or Grow Lamp bulbs, available at garden stores. Do not use ordinary household lights, such as incandescent bulbs or fluorescent tubes, because they greatly distort the appearance of paint colors and actually make some shades indistinguishable from others. Incandescent lights make colors appear richer than they actually are, leading to the under-compensation of mixed tones on the palette. This results in a pale, washed-out appearance of the portrait in daylight. Conversely, fluorescent lights bleach colors and give them a yellow cast, leading to overcompensation on the palette. This leads to a painting too brightly colored in daylight.

To make a packing-tape palette, place two slightly overlapping strips side by side somewhere on the canvas. The transparency of the tape allows the dove gray tint of the canvas surface to show through the palette, aiding in color matching. Also use the tape to attach the original photo to the canvas in some comfortable location. Having the canvas, palette, and photo on the same plane with respect to you and the lights assures you even illumination without glare while you paint.

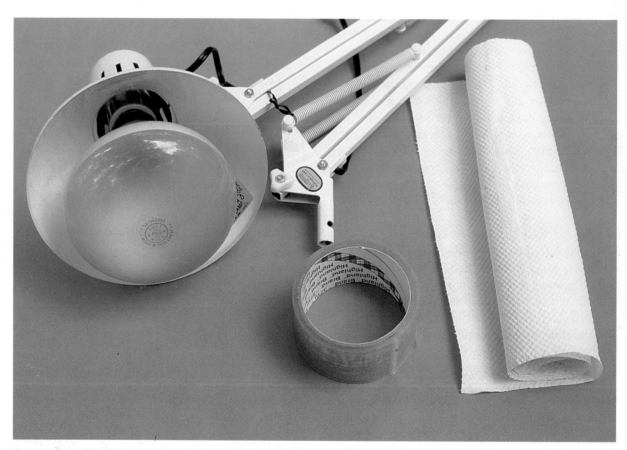

These supplies, along with an easel, are indispensable for setting up a studio for portrait painting.

Preparing the Canvas

A store-bought canvas comes prestretched over a stretcher bar frame, but it is neither tight enough nor smooth enough for our purposes. The canvas must first be stretched tighter for a good, firm work surface, and then refinished to make that surface as smooth as possible. Tightening the canvas also avoids possible thread damage during the surface refinishing process, in which sandpaper could scuff the threads in a slack canvas and leave a permanent impression of the supporting frame.

The frame consists of four bars that fit together in the form of slip joints at the four corners. The frame is held together by the force of the stretched canvas.

Eight wooden or plastic wedges are included with most brands of canvases. There are two slots in each of the four corners at the joints of the stretcher bar frame. Press a wedge into each slot with the straight side of the wedge sliding along the frame. Then use a lightweight hammer to tap each of the eight wedges deeper into its slot, rotating from one wedge to another as you work. This will stretch the canvas evenly. You will see the unglued joints at the four corners separate slightly, causing the surface to tighten as the frame strains against the canvas that holds it.

MAKING THE CANVAS SMOOTHER

A store-bought canvas comes preprimed, but its surface is not smooth enough for the fine detail work required for a realistic painting style. The peaks and valleys of the threads break up brushstrokes and impede the smooth flow of paint. The roughness of the surface also wears out brushes with its grating action.

The choice of canvas or other woven fabric as a painting surface is partly traditional and partly to hold heavy deposits of paint associated with oils—as, for example, with the impressionist painting style. But for a fine realistic style of painting, the canvas must be smooth enough to bear scrutiny up close, at mere inches, and not reveal the fabric weave or individual brushstrokes. This latter effect is mostly a matter of blending techniques, but a rough surface can defeat your best efforts for a

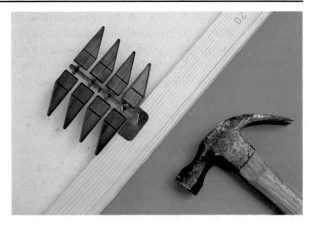

Wedges are usually included with a canvas.

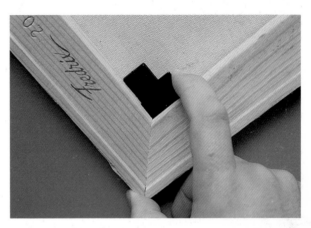

Each corner has two slots where wedges can be pressed into place.

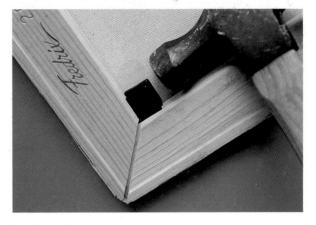

Tap the wedges into place.

smoothly finished portrait. If the canvas is smooth and sanded, you can use paint right out of the tube, which is the ideal consistency for our purposes.

Once the canvas has been stretched tight, place it face up and flat on a table. Then firmly bear down and sand the surface from edge to edge with back-and-forth strokes. Ample powder should rise off the surface. Be careful not to sand through the preprimed coat and expose the fibers underneath. Also, do not press so hard into the canvas that the sandpaper shaves a permanent imprint of the stretcher bars below into the canvas surface.

We will reprime the canvas with an undercoating more than once, next, but this sanding procedure must be performed before every coating.

PRIMING THE CANVAS
The first step in repriming is to take a paper towel and wipe off the residue of powder that formed on the surface during sanding. With the sponge brush, apply a thin coat of odorless thinner to the canvas, covering every inch of its surface with no missed spots. Let the canvas dry before repeating the sanding and priming at least twice more. The canvas dries more quickly in the sun or some other mild heat source, such as a hair drier. Fanning the canvas does not help much.

Reprime the canvas a total of at least two times. The last coat should be a dove gray color mixed by adding a small quantity of black acrylic paint to some odorless thinner. The dove gray tint we give to the surface subdues the blinding brilliance of a white canvas that interferes with color judgment by making any mixed tone appear darker by contrast than it would on a darker surface. The idea is to have the areas you paint first (when the surrounding canvas is still unpainted) harmonize with the areas you paint last (when the surrounding canvas is painted, and therefore darker). A dove gray background color makes this much easier.

We do not consider the canvas fabric as the painting surface, but the many coats of primer instead. For this reason the primer must be of the highest quality to do justice to your careful rendering. Artists rely on gesso, available under numerous brand names. It is actually chalk pigments suspended in what amounts to a liquid plastic medium composed of acrylic and other additives. Its exceedingly flat finish gives it a fine tooth for the adhesion of either acrylic paints or oils. Gesso also prevents oil paints from reaching the canvas fabric. Oil contains acids that are destructive to natural fibers over time.

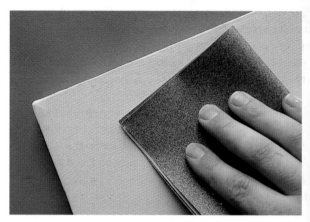

Using a sheet of medium-grade sandpaper folded to approximately a 4 x 5" square, sand the canvas firmly. Repeat this procedure before each coat of priming.

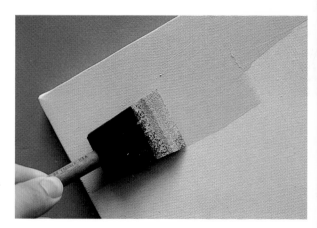

Reprime the canvas at least twice. Sand it and wipe off the dust between coats.

Selecting Photographs

The photograph you pick of your subject should be of studio quality—that is, it should be taken under controlled lighting conditions and with minimum camera vibration, usually with the camera bolted to a tripod. Such photos have the best chance of sharp focus and good color. Most people have at least school photos of children, which are of this quality.

LIGHTING FOR STUDIO-QUALITY PHOTOGRAPHS
Controlled lighting is either standard lighting or creative lighting. These terms refer to the type of lights used during photography and the manner in which they are arranged to cause shading across the subject.

In visual arts, compositions exist when subjects find themselves bathed in light of any description. We are most interested in standard lighting because it ensures even distribution of shadows across a subject. In portraits this means that the front and sides of the face are visibly illuminated, with the surfaces that project furthest forward quite light: the forehead, eyebrows, cheeks, chin, vertical ridge of the nose, and so on. Receding surfaces are shaded, and creases are quite dark.

Creative lighting goes beyond just the function of making your subject visible, but plays a more dramatic role in creating your composition. Once you have mastered the painting tools of your trade as portrait artist, then creativity can be pursued

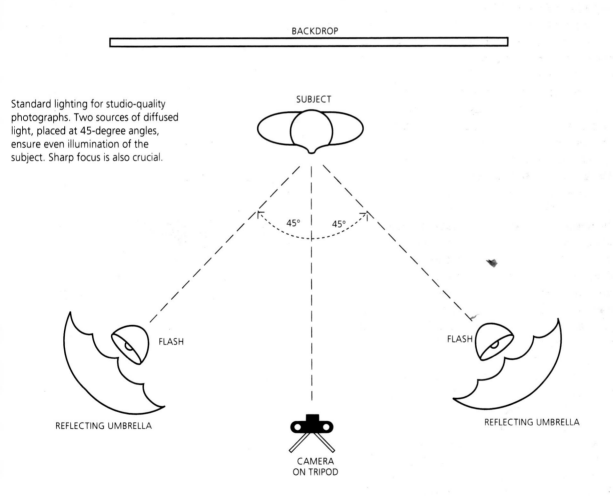

Standard lighting for studio-quality photographs. Two sources of diffused light, placed at 45-degree angles, ensure even illumination of the subject. Sharp focus is also crucial.

BACKDROP

SUBJECT

45° 45°

FLASH

FLASH

REFLECTING UMBRELLA

REFLECTING UMBRELLA

CAMERA
ON TRIPOD

with greater success in the areas of lighting, distribution of shape, perspective, and other aspects of composition.

Standard lighting uses at least two light sources, either flash units or floodlights. In this book, only the flash type was used to prepare photographs for paintings. An additional third flash unit is often used to illuminate the background, but throughout this book, our interest is in simplicity and economy, which the two-light system serves well.

In the standard arrangement of a two-light system, the lights are placed at a 45-degree angle from the subject, above eye level. The burst of light from the flash units must be diffused so that it does not "scorch" the subject. Diffused light leaves soft shadows and light areas across a subject, with plenty of contrast for characteristic shapes and contours to remain evident.

To achieve this, each flash unit actually fires directly *away* from the subject into an umbrella, which reflects a bright, even glow of light over the subject from its respective angle. The light sources are high enough above eye level to lighten the hair as well as the surfaces on the face that project forward furthest, but not so high that the eyes are shrouded in shadow under the brows.

You can take your own studio-quality photos using a 35mm camera, which is both economical and practical. The film for this camera can be purchased and processed everywhere. A single light source—the flash on your 35mm camera— will work with a white board or sheet acting as a second light. Position it close to the subject but out of camera view, where a secondary reflection off its surface from the flash on your camera illuminates that side of the face.

You can further reproduce standard lighting without professional equipment by using the sun, a bright window, or a table lamp as one light source and the flash on your camera as the second light. Colored filters that attach to the front of the camera lens can correct the complexion that is sometimes off when different types of light sources are used. You must experiment to get a feel for what to expect.

A WORD ON SNAPSHOTS

Snapshots are sometimes all that a client has left of someone—pictures snapped at some family gathering. They are different from studio-quality photos because they are "point-and-shoot" photos, often taken with available light. Although some fortunate snapshots are nearly studio-quality, these are the exceptions. No snapshots were used in any of the paintings in this book.

In most snapshots, subjects are posed informally or not at all, and extraneous material is often present. Though very creative compositions can come out of such spontaneity, more often than not, shadows are less attractively distributed across a face, with features sometimes hidden. Such photographs are more difficult to paint from, and such portraits should be attempted only after you have practiced a number of portraits taken under standard lighting, where shading is predictable.

Composing Portrait Paintings

The demonstration paintings in this book were painted from studio-quality photos, some available and others taken by me. In all cases the composition was kept simple: head-and-shoulder poses with a plain background, except for the hands and more extensive clothing included for the seated man.

This is possibly the simplest composition for a portrait: a head-and-shoulder pose on a plain background. The canvas size was kept small, 11 x 14", so that its principal purpose of instruction was served. This demonstration is the most detailed of all, and therefore it comes first so that you are given an intricate step-by-step guide to the portrait painting process. It is so detailed that you can paint it along with me, if you like.

Since this ideal studio-quality photo was provided, all I had to do was to crop the photograph to a head-and-shoulder composition to simplify the portrait even further.

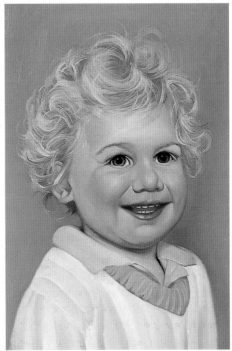

I took this photo with a standard lighting setup, trying to find a straight-on, symmetrical pose with both ears showing. Make-up around the subject's eyes and on her lips was a welcome challenge in the second painting demonstration.

She was seated sideways in a chair with her arm leaning on the back. This helped give a good line to her shoulders and allowed many attractive tilts of her head. During the sitting nothing was changed from one pose to the next except the facial expression and positioning of the head and shoulders. Placement of her hands and the appearance of the bottom of the blanket were not important.

A light blue blanket was used for the background and hung far enough behind her so that it would fall slightly out of focus, a technique that gives a sharp edge to a subject's profile.

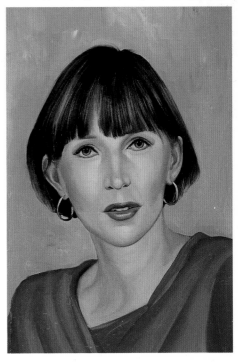

Setting Up the Projector

By using a slide projector and a 35mm slide copy of the original photograph, we can prepare a pencil drawing on the canvas before painting. Slide projection is an accurate way to compose a portrait. It allows you to place, scale, and rotate your image prior to drawing it. It also enables you to make compositions from multiple photos, even from different-size enlargements so that heads of different sizes can be matched. If you like, you can scale and include a background from a third photo.

Consumer 35mm slide projectors can be found in camera stores. The projection method is still no guarantee of a true likeness because the drawing is quickly covered with paint. It requires the systematic approach this book offers to maintain the likeness consistently.

Prepare for projection by placing the projector on a table. Hang the canvas on an opposing wall or set it on an easel, secured at an appropriate height. Then adjust the head size of the subject by moving the projector either closer to or further away from the canvas, and correct the focus.

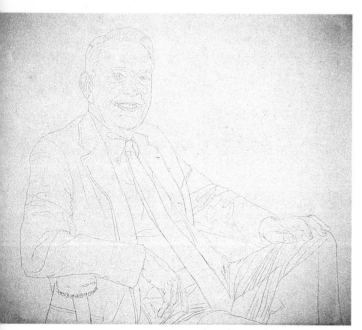

The compositions featured in this book are uncomplicated, and the drawings are simply accurate pencil outlines with no shading. This is the drawing for Skill Level Three.

Image distortion occurs when the canvas is not quite at a right angle (90 degrees) with the projection beam. Avoid a distorted image by positioning the table so that the projector's beam is horizontal. In this case, the image fits squarely on the canvas. Use books as props to fine-tune this right-angle projection. With the slide and projector in place, you are ready to draw the image.

Suppose your client has given you only the original photo print and no slide copy. If you have a 35mm camera and are familiar with using slide film, photographing the picture you are painting is the simplest way to produce a slide copy. Otherwise your friendly photo processor will assist you.

For copying, the photo must be framed squarely in the viewfinder of the camera with its outer edges showing. The camera must be held very still, preferably bolted to a tripod. Take the picture outside in daylight for best results.

DRAWING AN OUTLINE

The drawing is simply an outline of all the edges visible in the projected image. It will serve as your map across the blank canvas. The sharp, well-defined features of the eyes, nose, and mouth are very important and must be rendered with crisp pencil lines.

A semidark room will allow the pencil lines to be visible during projection. A room too light will wash out the projection. When the image is in place and you are seated comfortably, watch for that fatal error of bumping the equipment and sending the image out of registration while you are drawing.

Use a sharp pencil—a standard no. 2 works fine—and follow all visible edges you can see in the projected image. The sharper, more defined edges are easy. Indicate more obscure edges, such as those surrounding the soft glow on a cheek, by approximating them as closely as you can.

Finally, wipe the drawing lightly with a paper towel and the odorless thinner, which is weak and therefore does not erase your pencil lines. This removes excess graphite and makes the lines easier to cover with paint later.

The Portrait Process

Where to begin painting the face is our first problem and where to continue our second.

The photos on this page show the several work areas assigned to Skill Level One, which illustrates a strategy all students ought to follow until they are proficient in rendering the various parts of the face.

Our strategy in Skill Level One begins with the grouping of related features of the face and the rest of the portrait into work areas. On canvas they are centered around concentrations of pencil lines, and in the photograph they surround sharply defined features.

We will paint the first portrait by rendering five work areas in the following order: the eyes area, nose area, mouth area, jaw area, and hair area. In later demonstrations we will also paint the hands area, as well as the clothes and background area.

Each work area has steps in common with others. Each has at its core a concentration of sharply defined detail outlined with crisp pencil lines such as the eyes, mouth, and nose. Other edges are obscure and drawn vaguely across featureless surfaces such as the cheeks and forehead. In either case, the pencil lines delineate shadows from light areas.

Each work area is begun only after the previous one is completed and at the darkest point corresponding to the photograph, with a matching mixed tone from the palette. As the original penciled lines become covered, finished work becomes our guide.

Tone selections are similar for all the work areas with some variations; the eyes have almost black pupils yet the darkest point of the nose area, the nostril interior, is a brown color; the mouth has reddish tones and not yellowish tones like those of the skin areas. Background and clothing can be of any color.

Each completed work area serves as guidance for the next. In this way the pencil drawing can be replaced methodically with an appropriate tone rather than randomly, and we can keep track of the likeness throughout the completion of the portrait.

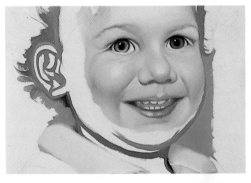

Left: End of the eyes area and beginning of the nose area in Skill Level One.
Right: End of the mouth area and beginning of the jaw area.

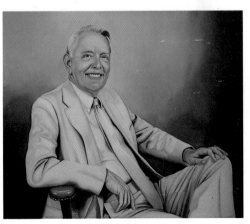

Beginning (detail) and end of Skill Level Three. Here the approach is more advanced and the different parts of the face are painted at the same time.

Mixing the Paint

We have already seen why an intended rendering is divided into various work areas, each rendered in a similar set of tones ranging from dark to light. The natural appearance of these tones in the finished portrait depends on their selection from the infinite range possible from the four basic colors and on their timely and proper distribution over the drawing on the canvas.

All complexions can be broadly classified as light or dark, although there are many subtle variations. Be sure to observe the photograph closely as you mix your paint. (Observing the subject in person is even better, if possible.) All the subjects in this book have light complexions, some lighter than others. Dark complexions are also briefly introduced because the tones for all are interrelated and developed in the mixing exercise. You are encouraged to follow along with me on a palette of your own and to repeat this exercise until you succeed in producing the intended mixed tones.

THE FOUR BASIC COLORS
The mixing exercise begins with the four basic colors:

Blue: French ultramarine

Red: cadmium red deep

Yellow: cadmium yellow medium

White: titanium white

Commercial names of paint are not standard, and formulations may vary considerably from brand to brand. Almost any brand of paint will do, but in the case of white, make sure it is quite opaque—densely pigmented.

In the demonstrations the tones are mixed as needed, not in advance as the mixing exercise would have it appear. Premixing tones could lock you into a generic skin tone for expediency, a trap many professional portrait artists fall into. All your portraits would then appear to have the same complexion when viewed together, and that would not do the subject or the client justice.

COLORS NEEDED FOR PORTRAIT PAINTING
It is important to note that we are talking about tone *groups*, approximations, not scientifically exact colors. Your version of cream orange may not be the same in every portrait you paint. Many of the colors you blend may be borderline tones that could fit into more than one group as a matter of judgment. The important thing is to work with the tones until they match what you see. This takes practice.

The definitions here of 12 unique tone groups are given in terms of their relative quantities of the four basic colors listed above, to give you an understanding of their relationship. The following are key symbols used in the tables that describe relative quantities of paint in descending order:

■ **Mostly.** The color is dominant.

▨ **Some.** The color noticeably influences the dominant color.

☐ **A little.** The color slightly influences the dominant color.

◆ **Trace**. The color is present in a very small amount, only because the mixed tone from which it is derived contained a little. Trace colors are never added directly from the four basic colors. (This concept will become clearer later on.)

None. The color is not present at all.

If different colors are prefixed with the same symbol, it means that they are present in about equal quantities.

Color	B	R	Y	W
Yellow black	■	☐	▨	
Red black	■	▨	☐	
Red brown	▨	▨	☐	
Yellow brown	▨	☐	▨	
Rose orange	☐	▨	☐	☐
Cream orange	☐	☐	▨	☐
Cream white	◆	◆	☐	■
Rose white	◆	☐	◆	■
Blue gray	■	☐	☐	☐
Light blue gray	▨	☐	☐	■
Yellow gray	▨	☐	▨	☐
Light yellow gray	☐	◆	☐	■

In practice the tones are mixed as we need them. When you blend colors, there are three sources of tone to work with: the palette, the brush, and tone already in the work area. Just as in the mixing exercise, you will alter previous tones already on your palette rather than starting from scratch each time and mixing each tone directly from the basic four colors.

SKIN TONE MIXES FOR LIGHT VERSUS DARK COMPLEXIONS

In a light complexion, all the tone groups appear yellower than the reddish tones associated with a dark complexion, except for the lightest tone, rose white. The skin tones are blended from the following gradually lightening sequence:

Yellow black

Yellow brown

Cream orange

Cream white

Rose white

In a dark complexion, all the tone groups starting with the darkest (red black) have red orange as their dominant component: some red and a little yellow. Only the lightest tone group, cream white, is derived from yellow orange. The skin tones are blended from this gradually lightening sequence:

Yellow black

Red black

Red brown

Rose orange

Cream white

Rose white

Yellow gray and light yellow gray are used for the teeth and whites of eyes, no matter what the subject's complexion. We will talk about eye color later.

SAMPLES OF THE 12 MIXED TONES

Below are approximate examples of the 12 mixed tones we will be using to paint portraits.

YELLOW BLACK

RED BLACK

RED BROWN

YELLOW BROWN

ROSE ORANGE

CREAM ORANGE

CREAM WHITE

ROSE WHITE

BLUE GRAY

LIGHT BLUE GRAY

YELLOW GRAY

LIGHT YELLOW GRAY

The Color Mixing Exercise

This exercise can be performed in a minute or two with practice. It will be helpful if you save one of your successful attempts as a sample palette to refer to in the future. The mixing exercise can be done either on canvas or on clear plastic tape, but the tape is a lot cheaper and can be peeled off and attached to other things, such as your next canvas.

Remember, in practice and during demonstrations, tones are mixed as they are needed and not before, as this exercise might imply. This ensures that the portrait painting has a personalized complexion. The standard selection of tones for either a light or a dark complexion is used as a general guide, but you should refine it according to the precise complexion of your subject, the lighting in the photograph, and so on.

Our approach to mixing color is to establish a basic mixed tone and then alter it by adding others. For skin tone we select orange as the basic mixed tone and alter it with either blue or white, or occasionally a little of both. This applies to both a light and a dark complexion, except that in the former we use a yellow orange and in the latter a red orange.

During the exercise, as you perform the blending process with the brush, attempt to blend away distinction among the various orange tones so that a smooth, seamless gradation of tones appears. Also try to physically smooth out the mixing area from the appearance of tire tracks through mud to that of a smooth, wave-washed beach.

Use the 3" clear plastic tape as your palette by placing two strips 6" long, one above the other but slightly overlapping, somewhere convenient on the canvas. Next squeeze out globs of the four oil colors in the same order on your palette from left to right: blue, red, yellow, and white. The quantity needed should cover no more than the area of a dime. Spread red into a 1 x 2" square and then do the same with yellow.

With repeated downward strokes of the brush, set the blending process in motion to join the two colors. Notice the variation of orange tones that results, ranging from a red orange on the left gradually turning into yellow orange on the right. Keep a paper towel handy and always wipe the brush on the towel before working with a different color.

Spread white below and along the band of orange tone. Rinse and dry the brush again. Then spread blue above and along the orange band of color. Wipe the brush to remove the excess white and to give it a flat shape. Proceed with the same downward strokes as before, beginning on the left where blue and red meet, and progressing gradually to the right, toward yellow.

Blend only the upper quarter of the orange with blue. Blending produces a dark purple—or red black, as we will call it—on the left between blue and red, but this tone turns quite dark black when the first of the yellow is reached; we will call this yellow black. If you progress too far into the yellow, the result will be a green black.

Because there is so much blue on the brush, rinse it in thinner and wipe it dry. Continue with the blending process between blue and orange. Concentrate on grabbing more of the orange with the brush and introducing it into the various black tones to produce a range of brown tones. Red brown is produced where red orange meets a little red black, and yellow brown occurs where yellow orange finds yellow black. Half of the original orange mixture should now remain below these brown tones for subsequent tinting with white.

With the same downward strokes as before, begin on the left where white and red orange meet. Progress gradually to the right, toward yellow orange, and observe the change. Focus only on the lower portion of the narrow band of orange that has remained, and blend it with white. This produces a light pink or rose white on the left between white and red orange, and a cream white toward the right between yellow orange and white.

Again, wipe the brush to remove stray and excess paint. Now proceed to blend the narrow band of remaining orange, starting on the left. Between the rose white and the red brown tones, rose orange emerges. Between cream white and yellow brown, cream orange appears. Blue is still present in the browns; when mixed with the white contained in the light tones, it subdues the brightness of the orange. Too much blue added to orange produces a blackish color; too much white produces a pale, earthy gray; and too much blue and white added to orange turn orange completely gray.

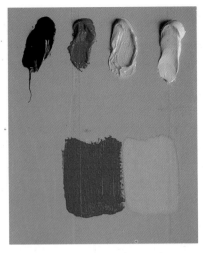

Lay out the four basic colors in order on your palette, and prepare red and yellow for blending.

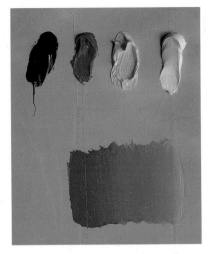

Blend red and yellow into a variety of orange tones.

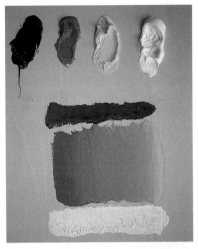

Now prepare white and blue for blending with orange.

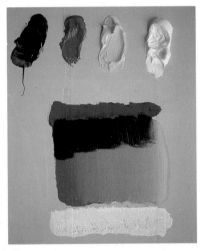

Orange mixed with blue produces red black and yellow black tones.

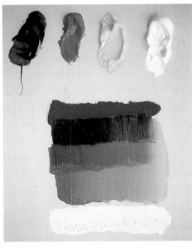

Black tones mixed with more orange produce red brown and yellow brown tones.

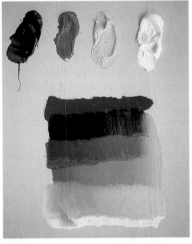

Orange tinted with white produces rose white and cream white tones.

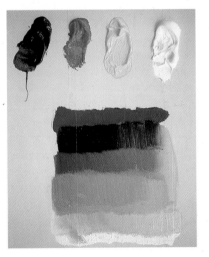

Brown tones mixed with more orange tones and white tones produce rose orange and cream orange tones.

Loading the Brush

A sharp-pointed brush works well in confined areas on the canvas.

A flat-shaped brush is useful for blending large areas and for covering the canvas more rapidly. It also provides a knife's edge for fine, crisp strokes, such as along the ends of hair.

A fanned brush shape allows parallel lines in one stroke, useful for the appearance of hair in a portrait.

Every time you load a brush, you will be taking a mixed tone from your palette to some work area on the canvas.

As always, wipe the brush after mixing a tone and before loading it. This ensures against any surprises on canvas. Load the brush heavily enough so that the hair can retain either a pointed, flat, or fanned shape, and so that during the brushstroke the paint flows freely from the hair but under your firm control.

The no. 1 and no. 3 round brushes can be given different shapes: fanned, flat, or with a sharp point. This is done by manipulating the brush on the palette as you are loading it, before you stroke it onto the canvas.

Stroking On the Paint

A correctly chosen mixed tone is stroked with the brush into the pools of light area left clear when the darker shadows were stroked into place before. Paint can be stroked either onto dry canvas or into wet paint already present there.

Stroking essentially rubs paint off the brush onto the canvas. As each work area progresses and holds more paint, this "rubbing off" is constantly improved upon until the stroking process actually becomes sophisticated blending. The brush takes on as much paint as it gives off, turning the brush and the blending area into an average tone of both.

The anatomy of a stroke along the path of its travel consists of a beginning, a middle, and an end. This is nowhere more evident than in the rendering of hair. Each stroke begins where the brush descends onto the canvas. The middle follows the intended path, and the end occurs as the brush lifts off the canvas. Though these three stages are described separately, they are of course executed in one pass. Subsequent strokes may overlap a given stroke, cross it, or otherwise alter it.

The beginning of a stroke often leaves a blemishing brush mark where the loaded brush touches the canvas. This mark should be minimized as part of the stroking process since subsequent stroking carries the burden of smoothing over these blemishes. Avoiding a blemish can be done by descending carefully onto the canvas, as a jetliner touches down on a runway.

It is repaired by pulling the middle or ends of subsequent strokes over the beginnings of preceding ones. In time this becomes an unconscious part of brush handling as you acquire a lighter touch with your hand.

During the middle of a brushstroke, the mixed tone flows from the very tip of the brush, but from higher up along the hair when you bear down on it. The shape of the brush can vary under your direction during the execution of a stroke. The middle of a stroke can be short, tightly curled, or long and wavy before the stroke reaches its end. Of course you need a sufficient load of paint to last the length of the stroke. You will find that a stroke runs out of paint a lot sooner across a dry canvas than across a wet undertone. Also, the stroke is broken up by the fabric weave of the canvas.

The middles of strokes make up the bulk of the texture of a finished portrait, with the beginnings and ends fading to an appropriate degree of obscurity. This allows the strokes to blend into wet undertones with a controlled distinction.

Just as our jetliner can take off far more smoothly than it lands, at the end of the stroke it is easier to avoid a brush mark than during the beginning. The brush's ascent off the canvas must always be carried through with delicacy, since this part of the stroke often remains visible, whereas other parts of the stroke may eventually be covered up by subsequent brushwork.

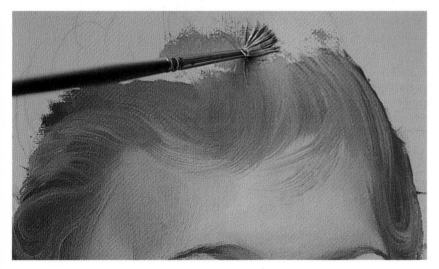

Throughout the face, strive to create the smooth texture of skin by blending the brushstrokes to make them invisible. When painting hair, however, do the opposite and allow the brushstrokes to resemble realistic strands of hair.

Blending

Blending is used wherever two tones touch each other on the canvas, to create a smooth, seamless edge. Sometimes this means working two tones into each other to create an average of the two over a broad area, as when rose white is blended with earlier yellower tones across the cheeks or forehead. But remember that delicate blending is also used even when there is a clear, sharp line, as between the edge of the face and the background, or between the edge of the iris and the white of the eye.

The photos on this page and the next one clearly illustrate how a tone is stroked into place and then blended into the surrounding wet tones already on the canvas. As a continuation of the same stroking motion that deposited a load of paint in the work area, brush action now blends the new tone into the undertones or surrounding tones. This produces realistic shape and skin tone.

Enough paint is deposited so that no canvas is visible through it. In the case of wet-over-wet stroking, the touch should be light enough to control the degree to which the new strokes fade into wet undertones. This skillful manipulation of the brush is the key to realistic painting. Blending controls the ebb and flow of contrast among the color differences of tones in the area and their overall differences of light and dark.

The relationship of shape and color in a portrait is the relationship of a true likeness and a true complexion. The relationship is ideal when contrast is correctly composed for a realistic complexion (differences in color content of tones), and a realistic shape (differences in light and dark character of tones regardless of color).

Blending results physically in a texture as rough as uncombed hair or as smooth as a child's cheek. In terms of color the blend results in a new tone that is an average by degree of the tone from the brush and one or more tones in the blended area on the canvas.

Wipe the brush as frequently as necessary, and even reload it with more of the same mixed tone if need be, to ensure thorough coverage of canvas and blending with tones.

Remember that blending is most effective when the undertones are wet. For example, if you finish

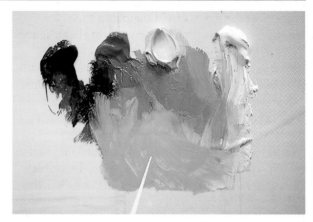
Here you see cream white mixed on the palette.

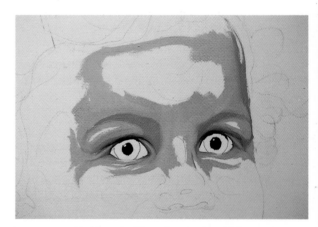
Next cream white is stroked into place on the canvas.

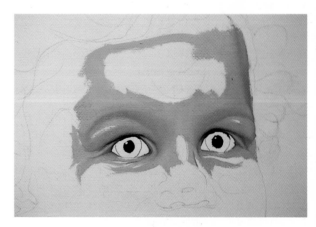
Cream white is blended into the surrounding wet tones.

one work area but wait several days before beginning the next one, the completed work will be nearly dry. You will have to rely on rewetting borders of the dry areas in matching tones for "seamless joining" with a minimum of disturbance.

The physical stroke directly affects realistic blending. The path of the stroke should bend with the shape of the intended feature, with light tones "chiseling" away at dark tones as if you were a sculptor. Do not just think two-dimensionally (up, down, left, and right with the surface of the canvas), but follow your sense of a third dimension recessing into and emerging out from the canvas. Blending strokes should follow a natural direction that describes form, as a river winds its way through a valley.

Cross-stroking in the blending process is occasionally permissible when brushing against the "natural path" might be necessary to change a natural contour with brute force, as during the clean-up process for the correction of error. Or you may want to do something as simple as dispersing fresh tone over an area such as putting blush tone on cheeks.

CLEANING UP

No matter how carefully you paint, you are bound to make slips now and then. These imperfections must be removed the moment you notice them, before you attempt anything new. Cleaning up prepares the area and the brush before the brush is reloaded with either the same or a different tone. This is especially important after you finish one work area and proceed to the next. Remember to wipe the brush frequently but not harshly.

If you correct the same area too many times, the paint will build up and cake on the canvas, causing physical tracks like tires through mud. Unfortunately these are very obvious even if there is no tone distinction. This kind of physical disturbance of surface texture must be smoothed out through further blending. But if underlayers have become tacky with drying, the new paint "tears" at the undertones like peanut butter over fresh bread. Repairing such a surface to a smooth finish is unlikely, and you may have to scrape off the top layers for reworking.

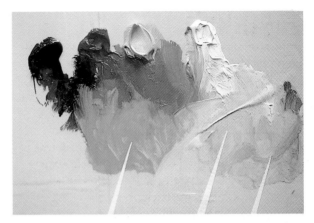

Cream white (left) is predominantly yellow. Rose white (center) and a slightly darker rose white (right) are mixed from white with a little red, and a slight daub of cream white from the preceding step. Remember that tones are general families; you should personalize them for your own painting rather than trying to match my palette precisely.

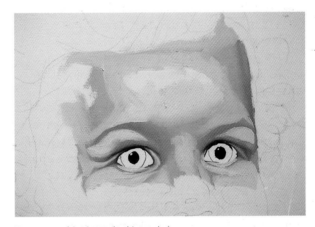

Now rose white is stroked into place.

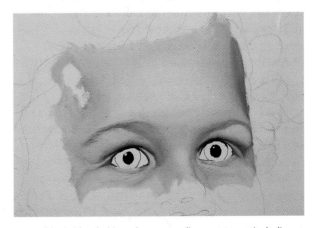

Rose white is blended into the surrounding wet tones, including cream white from the preceding step.

Skill Level One:
Portrait of a Young Child

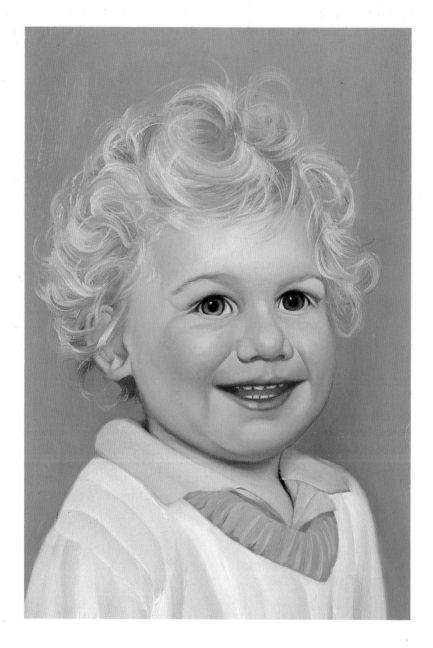

It is important that you refer frequently to this demonstration after you move on to Skill Levels Two, Three, and Four, since this first demonstration illustrates every step in detail. As you work on, say, the eyes in a later portrait, you should refer back to the eyes in this one as a more detailed reminder.

The portrait I will paint in Skill Level One is of a young child. He is posed especially for this book in a way that shows the best aspects of a head-and-shoulder pose to teach portrait painting. For example, both eyes are open, displaying clearly all their attractive features under excellent illumination. The head is turned in such a way that we can see at least one ear, and the lips are parted in a lovely smile revealing some teeth.

Each of the steps in this demonstration is similar to the order of procedure described on pages 20 through 27. We will assume that you have already set up your studio and prepared your canvas. Relational comparisons can be made between paragraphs of one step of a chapter and their counterparts in other steps. These titles and the order they appear in each step are:

Mixing

Loading the Brush

Stroking On the Paint

Blending

Cleaning Up

Photographs are taken of the work area on the canvas at the end of the step where it appears to show the progress since the preceding step.

There are also photographs of the palette taken at the same time as the canvas photos. These photos show the color mixing process from step to step. The photo for each step usually coincides with the change in mixed tone; for a light complexion that would be yellow black, yellow brown, cream orange, cream white, and rose white.

Some deviation from this norm does occur in some work areas; for example, the darkest tone in the nose area is yellow brown. We use random color to suit taste in rendering the subject's clothing and background.

MIXING
In these paragraphs we consider the palette and which tone should be mixed next for the current step, as well as how to mix it.

LOADING THE BRUSH
Here we decide which brush to use. For most of the portrait, there are three to pick from, a no. 1 round, a no. 3 round, and a no. 6 flat. (The fourth brush, the no. 12 flat shader, is for use in a plain background.) We also decide whether the round brush should be shaped pointed, flat, or fanned during the loading of paint.

STROKING ON THE PAINT
In these paragraphs we contemplate and perform the actual stroking of the loaded brush onto the canvas. We consider the exact location of the stroke and the manner in which the brush should be handled.

BLENDING
For realistic rendering of a true likeness, blending is the crucial skill of brush handling. It guides the physical spreading of paint across the canvas and makes the various tones flow together to create a realistic impression of the subject's facial shape and complexion.

CLEANING UP
In these paragraphs you are reminded of what repair work and clean-up work may be needed before you go to the next step. A stray streak of the wrong color of paint in the wrong place can cause a problem later by blending with whatever color you try to paint over it.

Eyes: The Pupils and Eyelashes

We begin with the darkest tone in the face of the photograph, located in each pupil and in the lash lines above.

MIXING
Mix yellow black, the darkest tone we can mix on the palette:

Color	B	R	Y	W
Yellow black	■	□	▨	

THE KEY TO THE SYMBOLS IS GIVEN ON PAGE 20

LOADING THE BRUSH
Begin with the no. 1 round liner brush, or the no. 3 if your drawing is larger than mine. Load the brush with yellow black and shape the brush hair to a point.

STROKING ON THE PAINT
Study the photograph and decide where to begin painting. It should be at the darkest point in the eye area: the pupils, which have a simple round shape. Stroke yellow black into each pupil from the inside outward. Correct the pupils' shape, improving on the pencil lines as you cover them. The iris is like a donut with the pupil being the hole. Each pupil should appear precisely centered within its iris.

Be careful to leave each eye's highlights clear until later, when we are working with a much lighter tone. Sometimes more than one highlight appears in each eye. Some are brighter than others, but there are the same number in both eyes, and they are in the same location—usually on the outer rim of each pupil. There will be as many highlights as there were light sources, such as flashbulbs that illuminated the face when the photo was taken.

With the pupils done, consider where else yellow black can be used in the eye area. The lines formed by the shadows of the upper eyelashes are quite dark even in a fair-haired person. In this photograph these lash lines appear to connect with the pupils, so yellow black should continue. Note, however, that the lash lines do not extend to the two inner eye corners as they do the outer corners, because the tear glands there impart a lighter, brighter, more colorful tone. This too is evident from studying the photograph.

BLENDING
Blending is not necessary in these first steps because no other tones are present.

CLEANING UP
Wipe the brush and straighten its hairs.

The four basic colors: blue, red, yellow, and white.

Mix yellow black.

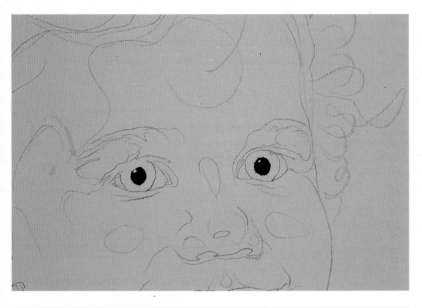

Begin the pupils, being careful to leave the highlights clear.

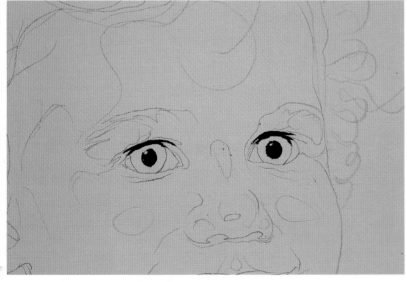

Begin the upper lash lines.

Eyes: The Eyelids

On consulting the original photograph, we see that a lighter tone than yellow black is needed to complete the lash lines. It is also the tone needed to begin the lid lines. Where shadows give way to light—for example where the lid unfolds—the richness of skin color begins to show at the shadowy edges. The lid lines are also of this rich middle tone, not as dark as the lash lines.

MIXING

Now we need to mix yellow brown, which has the richness we need from its greater orange content. We will not mix it from scratch, but by adding colors to the yellow black already on the palette. Let's take a closer look at how this is done:

Color	B	R	Y	W
Yellow black	■	□	▨	
Yellow brown	▨	□	▨	
To mix yellow brown from yellow black, add:*			▨	▨

THE KEY TO THE SYMBOLS IS GIVEN ON PAGE 20

*Add more yellow than red, to avoid mixing red brown.

Adding red and yellow reduces the relative proportion of blue. Remember, in this demonstration we are painting a light complexion rather than a dark complexion, which would require red brown. Notice that the mixing pool—that is, the area of the palette where we are actually mixing colors—is beginning to grow.

LOADING THE BRUSH

Load yellow brown and shape the hairs of your brush to a point. You should still be using the no. 1 or no. 3 round brush.

STROKING ON THE PAINT

We will now stroke on yellow brown to blend with yellow black, sealing it off and extending the lash lines further into and around the outer and inner corners of the eyes. The lid lines are begun at their darkest point, which is the deepest part of the crease.

Stroke the load of paint along the yellow black of the lash lines. The lash lines are, in effect, trimmed. The two tones touch but do not destroy each other.

Extend the lash lines into the inner eye corners and around the outer corners of the eyes, but not onto the lower lids, because they are a much lighter tone. Reload the mixed tone when necessary. Begin each lid line with a thin stroke, and follow its curvature carefully with respect to the lash line. The extent to which these two lines are parallel determines much of the character of the eye. On occasion the lid and the lash lines may converge above the pupil, so that their separation is visible only at the eye corners.

At this point in every step, study the photograph and consider where else in the immediate area the current tone can be used, but do not venture outside the present work area. You could lose track of the likeness if the pencil lines are covered too soon. This is the greater risk encountered when painting with the more advanced approach of Demonstrations Two through Four later in this book.

BLENDING

Blend wherever yellow brown comes into contact with yellow black. The blend is slight with neither tone overpowering the other. The two tones "melt" together but remain distinct.

CLEANING UP

Cleaning up is still limited to wiping the brush.

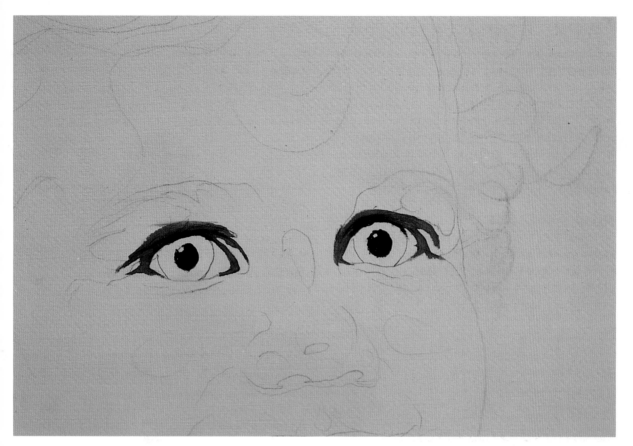

Complete the lash lines and begin the upper lid lines.

Mix yellow brown (right) from yellow black (left), making sure not to mix red brown (center).

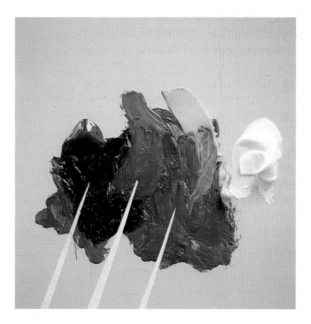

Eyes: The Eyebrows

In this step we will paint the eyebrows and more of the contours surrounding the eyes. Remember that even if the eyebrows themselves are a light color, they should still be painted with a darker color first because of the shadow cast by the bone structure around the eyes, as well as the protruding hairs of the eyebrows.

MIXING

Mix cream orange, the next tone group after yellow brown in the selection for a light complexion. Again, we will do this not from scratch, but from the yellow brown already on the palette.

Color	B	R	Y	W
Yellow brown	■	☐	■	
Cream orange	☐	☐	■	☐
To mix cream orange from yellow brown, add:		☐	■	☐

THE KEY TO THE SYMBOLS IS GIVEN ON PAGE 20

Adding red and yellow further reduces the proportion of blue, and adding white makes a creamy color from what would otherwise be a very bright orange. Cream orange is still not very light but quite distinct from the darker tones so far. This tone is as colorful as yellow brown but lacks the earthiness of brown and instead has a rich, creamy appearance.

LOADING THE BRUSH

Load cream orange onto your no. 1 or no. 3 round brush and shape the hair flat.

STROKING ON THE PAINT

Use cream orange to surround yellow brown and yellow black, effectively sealing them off from the lighter tones that will be added later. The cream orange further serves to expand the lash and lid lines.

Begin each eyebrow with a substantial stroke to indicate its location and approximate shape. Any greater accuracy of the brows or hair detail is not necessary because extensive reshaping of these approximated brows will occur from above and below when we return with lighter tones later. Stroke the load of cream orange along the previous yellow brown areas of the eyelashes. Continue along the newly created lid lines and extend them further toward the inner and outer corners into the vicinity of the lash lines, where they unfold together into open areas approaching the temples. There the surface contours tend to connect them with the brows.

At the inside corners of the eyes, the lids unfold and connect with the ends of the brows and the sides of the nose at the bridge. Stroke the slight shadow under each lower lid. The soft creases begin at the inner eye corners and curve outward around the lower lids but remain above the cheeks.

BLENDING

Blend where various tones meet. Blending is becoming more necessary now that more tones are present in the work area and flowing together, sometimes inadvertently under the more extensive brushstrokes that now prevail. Keeping the point of the brush shaped flat will help it blend more smoothly.

CLEANING UP

Clean up the brushstroked areas. Take more notice now of cleaning up the area before continuing; don't leave strokes unblended. Wipe the brush.

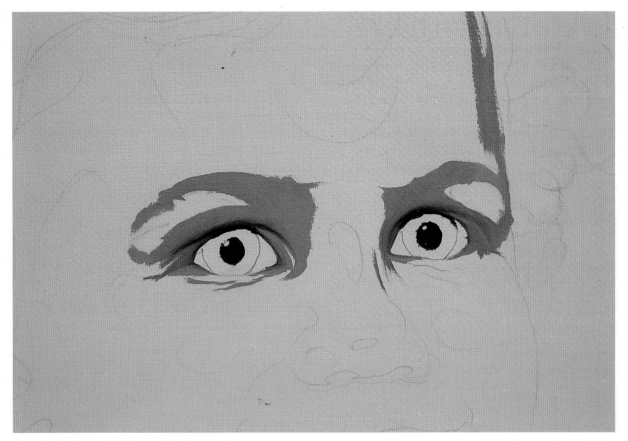

Complete the lash and lid lines and begin the eyebrows.

Mix cream orange.

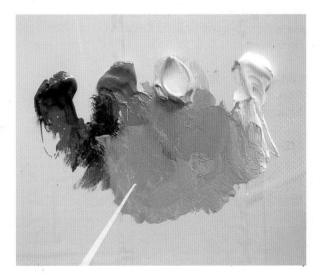

Eyes: Blocking In the Lighter Tones

By the end of this step, the structure of this part of the face will be defined by a range of tones from light to dark, but that range will still be only halfway complete. The overall complexion of the work area should still look quite dark. These shadow tones will be blended more as lighter tones follow.

MIXING

Mix cream white by adding to the colors already on your palette.

Color	B	R	Y	W
Cream orange	☐	☐	▨	☐
Cream white	◆	◆	☐	■
To mix cream white from cream orange, add:			☐	■

THE KEY TO THE SYMBOLS IS GIVEN ON PAGE 20

Note that cream white contains a trace of blue and red because it is mixed from cream orange, which contains a little of each. By the time you add the yellow and white, the presence of blue and red is practically invisible—but even so, they tone down what would otherwise be a pale yellow into a subtler, creamier hue.

The middle tones at the edge of shadows appear lighter but less bright and more creamy than cream orange. The slight remaining traces of red and blue tone down the color somewhat and prevent it from becoming too unnaturally bright.

LOADING THE BRUSH

If you have been using the no. 1 brush so far, switch to the no. 3 round; if you have been using the no. 3 so far, continue with it. Load the cream white onto your brush, and shape the brush flat to sweep broader areas at a time.

STROKING ON THE PAINT

Stroke on the load of cream white and continue trimming around the previous cream orange work, connecting islands of paint.

Cream white is used not only to surround previous tones and blend with them, but to connect all the islands of paint scattered across the eyes area. This further isolates pools of unpainted primed canvas, which represent highlights of the skin in the original photograph: the puffiness under the brows as well as the forehead above them, between the eyes at the top of the nose, along the crest of the upper lids between the lash and lid lines (not yet the lower lids), and around the tear glands of the inner eye corners.

BLENDING

Blend tones wherever they meet. Blending sculpts shape by the degree to which one tone is pushed into another. Contrast is balanced between tones of light and shadow area, edges are made either sharper or more obscure, which simulates the thickness of folds in the skin and puffiness of surfaces such as the brows. Complexion is not a concern until rose white, a very contrasting tone, is introduced next.

Distinctions between tones are initially sharp during stroking, but with subsequent blending these distinctions lessen to a point where the smooth transition of tone translates into realistic shape. If blending is overdone, however, the tones appear too similar with a corresponding loss of shape: The face will look flat.

CLEANING UP

As the work area becomes more saturated with paint, there is greater potential for error. As always, remove brush marks, correct errors, and wipe the brush.

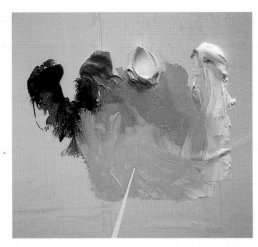

Mix cream white.

Block in the rest of the skin in the eyes area, all except the palest sections, with cream white.

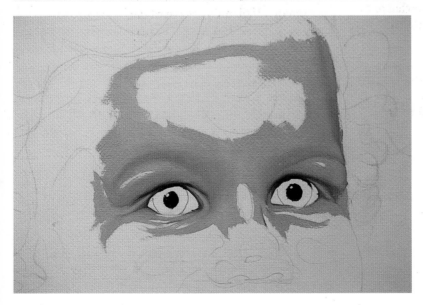

Blend the cream white with previous wet tones. Here you can see the subtle results of blending, especially around the eyebrows and eyes.

Eyes: Making the Skin Tones Realistic

Consider realistic shape and skin tone when you reach this step in every work area. We have now given a correct underlying structure to the eyes area but must now develop it into realistic shape, as well as finish it with a realistic skin tone. For this light complexion, all the tones we have used so far have been predominantly yellow. We now need a redder tone, rose white, to set up the necessary blend of yellow and red that gives the appearance of realistic shape and skin tone.

MIXING
Mix rose white by adding a little red to lots of white, and adding a daub of the cream white already on your palette.

Color	B	R	Y	W
Rose white	♦	☐	♦	■

THE KEY TO THE SYMBOLS IS GIVEN ON PAGE 20

When rose white is stroked into the pools left clear on the canvas, it has a distinct red cast that contrasts dramatically with the yellow cast of the previous tones. This contrast is responsible for the sudden realistic appearance of shape and true complexion.

LOADING THE BRUSH
Now load some rose white onto your brush. Continue using the no. 3 round brush below the brows and around the eyelids. Use the no. 6 flat to work beyond these areas into the forehead and the tops of the cheeks.

Remember to wipe the brush between loadings, since it will pick up more and more stray pigment off the canvas.

STROKING ON THE PAINT
Stroke the load of rose white onto the *lightest* point of each highlighted skin area in turn. (This is different from our approach so far of stroking on the paint at the darkest area first, because rose white provides highlights rather than shadows.)

Stroke rose white into every island of canvas unpainted so far, to represent the highlights on the skin. At this stage, the entire eyes area is saturated with wet paint. (The only exception is the eyes themselves, which we will finish later.) Stroking and blending tones becomes more difficult, but this wet-on-wet process is indispensable to realistic shape and skin tone.

BLENDING
From this lightest point, blend rose white outward into the surrounding tones. The colors will blend on the canvas to an average tone somewhere between rose white and the others. This is ideal and facilitates a harmonious bridge between the red versus yellow contrasting tones.

The degree to which rose white overpowers the other tones or gives way to them gives you perfect control of shape and its companion, skin tone. This blending process also determines sharp or soft edges and the illusion of rising and falling surface.

Building shape is the sweeping of one tone through another and smoothing away of tone distinctions to a balanced contrast with skillful brush handling and tone recognition. It requires correct anticipation of changes in surface planes as shadows give way to light—that is, as one tone gradually gives way to another. The finished effect of this should naturally mirror the photograph, where chemical dyes did the job. So study your photo closely at all times. It is, after all, a rendering of sorts.

CLEANING UP
Clean up visible brush marks, and wipe the brush.

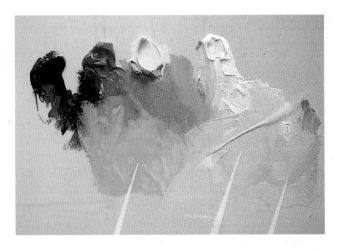

Mix rose white (center), balancing it from darker (right) to lighter and from yellower to redder. A slight touch of cream white from the preceding step (left) is necessary to prevent rose white from being too unnaturally pink.

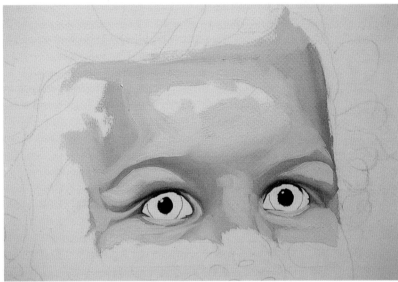

When rose white is blocked in, it forms a dramatic contrast with the earlier, yellower tones.

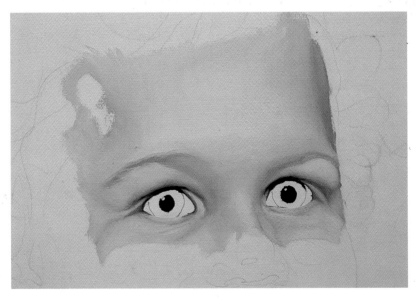

Blending the rose white with the earlier tones creates a dramatic improvement in the realistic appearance of the eyes area.

Eyes: Beginning the Iris

The eyeballs might be considered a mini work area requiring another cycle of color mixing. In a sense, we have already painted them indirectly, since we skirted the whites of the eyes with wet paint.

For the sake of this demonstration, I am painting one eye brown and the other blue. These are the two most common eye colors, and other variations—green, hazel, and so on—can be mixed by altering these two basic colors slightly. The procedure for starting any eye color is the same.

MIXING

If yellow black is not still available on your palette, mix it from scratch.

Color	B	R	Y	W
Yellow black	■	□	▨	

THE KEY TO THE SYMBOLS IS GIVEN ON PAGE 20

LOADING THE BRUSH

Load the no. 3 round liner brush to which we return, and shape it to a point.

STROKING ON THE PAINT

To complete the eyes, we begin with the outer rim of each iris by returning to the upper line of eyelashes. Using the same mixed tone as for the lashes, yellow black, stroke each iris along its outer rim where it emerges from under the lash line. Think of the outer edge of a donut having the pupil for its hole. This outer rim circles around, down to the lower lid behind which each iris may hide a little. Take this opportunity to correct the roundness of the iris over the indications of the pencil lines. The pupils should be in the iris centers and match in size. Also notice that the upper half of the iris darkens under the shadow of the eyelashes, whereas the lower half is substantially illuminated. This is because the entire upper half of each eyeball is shrouded in shadow by the upper lid and eyebrow.

BLENDING

Blend where the iris and the lash lines meet. Blending is limited here to the iris rims where they emerge from under the lash lines.

CLEANING UP

Clean up as usual. Wipe the brush to straighten the hair.

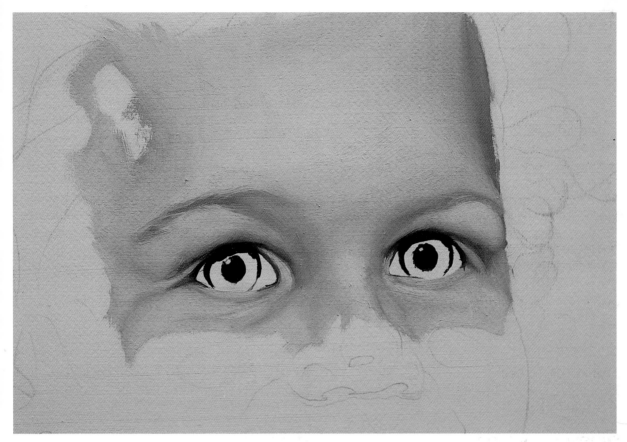

Begin the iris at the outer rim.

Mix yellow black.

Eyes: Filling in the Iris Color

The dark tones added in the last step and this one represent the structure of the iris, just as earlier dark brown tones represented the structure of the eye area. Their actual color will be more evident with the next tone.

Sometimes the subject's eye color is not evident from the photo; often (as in this example) it will appear darker than it really is. In such cases, your best option is to observe the subject in person if possible, or ask your client for a description of the subject's eyes. If you paint them a basic brown or blue, minor adjustments to the color can be made later after the client sees the portrait.

MIXING
If the subject has brown eyes, mix yellow brown from yellow black, just as before.

Color	B	R	Y	W
Yellow black	■	□	■	
Yellow brown	■	□	■	
To mix yellow brown from yellow black, add:˙			■	■

THE KEY TO THE SYMBOLS IS GIVEN ON PAGE 20

˙Add more yellow than red, to avoid mixing red brown.

If the subject has blue eyes, mix blue gray from yellow black.

Color	B	R	Y	W
Yellow black	■	□	■	
Blue gray	■	□	□	□
To mix blue gray from yellow black, add:˙	□			□

THE KEY TO THE SYMBOLS IS GIVEN ON PAGE 20

*The small amounts of red and yellow are important to prevent blue gray from turning bright blue.

LOADING THE BRUSH
Load your no. 3 round brush with either tone and shape it to a sharp point.

STROKING ON THE PAINT
Fill in the upper half of each iris with yellow brown for brown eyes and blue gray for blue eyes. (Leave the highlights clear until we do the whites of the eyes.) The pupils should still be wet with yellow black. Also stroke yellow brown or blue gray around the inner rim of each iris—that is, around the outer edge of each pupil.

Reshape or locate the pupils more accurately by trimming or expanding them. In most portraits, the pupils should be perfectly round and centered in each iris. However, if the subject was not gazing straight into the camera, the pupils and irises may be slightly elliptical. Be sure to refer to the photograph before finalizing their shape.

Now complete the outer rim of each iris down to the lower lid. The upper half of each iris is now filled in, but the lower half has a band of unpainted primed canvas between the two bands of color, left for a lighter tone.

BLENDING
Blend the blue gray or yellow brown with the yellow black of the eyelashes, the extreme outer edges of the irises, and the outer edges of the pupils. All these edges are quite distinct, so be careful to blend them very delicately.

CLEANING UP
Correct errors such as overly trimmed or different-size pupils by filling them in again with yellow black.

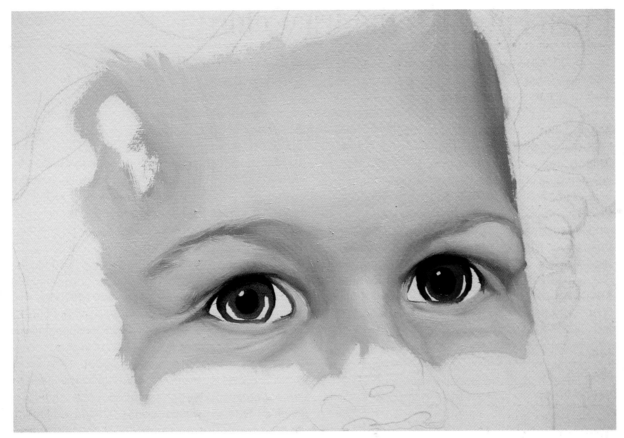

Fill in the top half of each iris. Remember that the iris color appears darkest at the top, where it is in the shadow of the eyebrows and upper eyelids with their lashes.

Mix blue gray (left) for blue eyes or yellow brown for brown eyes.

Eyes: Finishing the Iris Realistically

As you know by now, the mixed tone names we have been using are labels for *families* of similar tones, and you should adjust them slightly to personalize them for your subject. For example, to make blue eyes greener, mix a little yellow brown with the blue gray. For hazel eyes, start with more cream orange than yellow brown, and add just a touch of blue to suggest a greenish cast.

MIXING
If the subject has brown eyes, mix cream orange as you did before.

Color	B	R	Y	W
Yellow brown	■	☐	■	
Cream orange	☐	☐	■	☐
To mix cream orange from yellow brown, add:		☐	■	☐

<div align="center">THE KEY TO THE SYMBOLS IS GIVEN ON PAGE 20</div>

If the subject has blue eyes, mix light blue gray.

Color	B	R	Y	W
Blue gray	■	☐	☐	☐
Light blue gray	■	☐	☐	■
To mix light blue gray from blue gray, add:				☐

<div align="center">THE KEY TO THE SYMBOLS IS GIVEN ON PAGE 20</div>

LOADING THE BRUSH
Load your no. 3 round brush with the applicable color, and retain its sharp point.

STROKING ON THE PAINT
Use cream orange or light blue gray to complete each iris by filling in its lower half. The tones must blend seamlessly with the darker ones above, with the outer rim right up to the lower lid, and around the outer edge of the pupil.

Now mix a lighter tone to impart a final realistic glow to the iris: Add a little yellow to cream orange in the case of brown eyes and more white to light blue gray for blue eyes. Stroke on this lighter color only very low in the iris, between the pupil and the lower lid.

BLENDING
Blend the top of the iris a little, where the iris color darkens as it merges with the lash line at the pupil. Work carefully; it is a small area. These final tones for the iris make them appear realistic and provide their true color with a sense of moisture. Do the same a second time with lighter variations of the same tones, especially along the iris below the pupil, where the iris color is lightest. See if this makes it look even more realistic. Keep blending to a minimum, just enough to remove tone distinctions that give a rough, unfinished appearance to the features. Still keep the highlights clear if possible.

CLEANING UP
Clean up by blending slightly to remove imperfections. Don't attempt to brush over these tones of the iris too often because you run the risk of muddying the delicate blend between them in such a confined space.

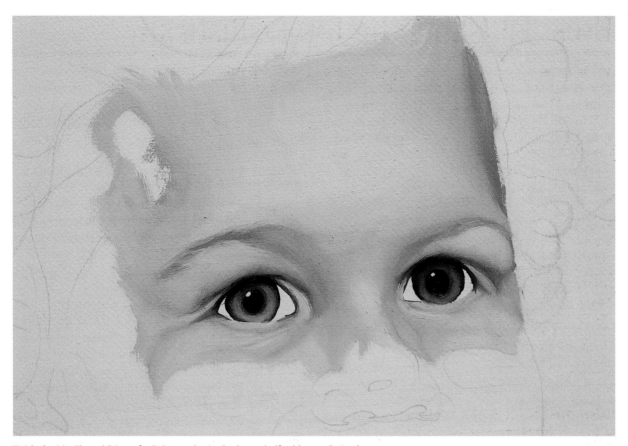

Finish the iris. The addition of a lighter color in the lower half adds a realistic glow.

Mix light blue gray (left) for blue eyes or cream orange for brown eyes.

Eyes: Preparing the White Area

We will prepare the whites of the eyes with yellow gray first in their shaded areas, and then light yellow gray to finish them and make them look white. This may sound peculiar, but close observation reveals that the "whites" of the eyes are not completely white, but rather a combination of whitish tones that makes the eyeballs look round. If we used only pure white to paint them, they would look absolutely flat.

MIXING

Mix yellow gray from yellow black.

Color	B	R	Y	W
Yellow black	■	☐	▦	
Yellow gray	▦	☐	▦	☐
To mix yellow gray from yellow black, add:			☐	☐

THE KEY TO THE SYMBOLS IS GIVEN ON PAGE 20

LOADING THE BRUSH

Load your no. 3 round brush, and keep it shaped to a point for the confined area in the eyes.

STROKING ON THE PAINT

Begin the whites of the eyes with yellow gray, which represents shading to make the eyeballs appear round. This shading occurs along the upper, darker half of each eyeball, where it recedes under the lash line and into the eye corners. At the lower lid there is no shading of the whites because they are very well illuminated.

Note that there are four triangles that represent the whites of the eyes. Each is demarcated by a lash line above, an outer iris rim, and a lower lid. They will vary in size depending on the direction of the subject's gaze. Their common characteristic is that, as part of the eyeball, their upper half darkens where it recedes under the lash line and into the outer corners. However, at the lower lids, they are quite light, especially at the triangle point where the iris and lower lid meet.

Work around the inside of each white triangle in turn, along the upper lash line and into the outer corners. It is now also possible to improve the shape of the iris as you work around it. At the inner triangles, confine the shading up under the lids at the outer iris rim to avoid contaminating the anticipated reddish area of the tear glands. Leave the lower, lighter portions of the triangles clear for a lighter yellow gray tone later.

BLENDING

Blend these shaded areas of the whites just slightly with the lash lines to the outer corners and the sides of the iris, but not the lower eyelid. (This is a very light area and will be blended in the next step.)

CLEANING UP

Clean up as before and wipe the brush.

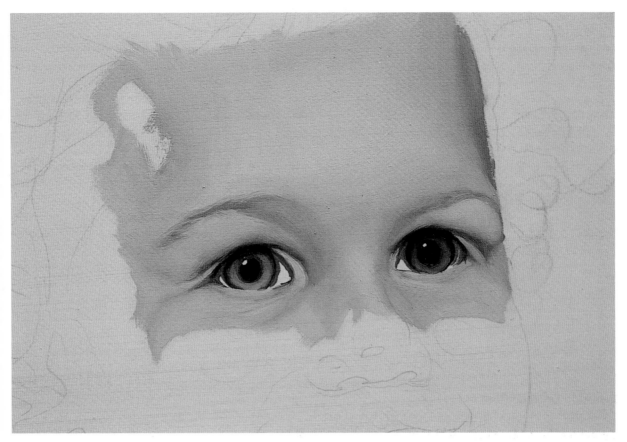

Begin the whites of the eyes.

Mix yellow gray.

Eyes: Finishing the White Area Realistically

This is a gratifying step because it makes the eyes look round, bright, and full of life.

MIXING
Mix light yellow gray from yellow gray.

Color	B	R	Y	W
Yellow gray	■	□	■	□
Light yellow gray	□	◆	□	■
To mix light yellow gray from yellow gray, add:				■

THE KEY TO THE SYMBOLS IS GIVEN ON PAGE 20

Since this is the last step in the eyes area, it is important to make any necessary adjustments and corrections to this work area now before we go on to the next one. Return to any of the previous tones as necessary to accomplish this.

LOADING THE BRUSH
Load the brush with the appropriate tone, and shape it into a point.

STROKING ON THE PAINT
Finish the eyes realistically with light yellow gray. The lightest point in the whites occurs in the lower part of each eyeball, where the whites and the iris disappear behind the lower lid.

At last we are ready to complete the highlights in the eyes. These are usually found on the upper edge of each pupil at the rim of the iris. There should be the same number in each eye, and they should be in the same location. Shape your brush into a sharp point, and just barely touch its tip to the canvas, using some of the same color you used to finish the whites of the eyes. Scrutinize the rest of the eyes area and make sure nothing is left undone before you go on to the next work area.

BLENDING
Blend light yellow gray carefully into the darker yellow gray. Very slight adjustments in the eyes can have dramatic effects.

Remember that during a lengthy blending procedure there are three instant sources of tone to work with: the palette, the brush, and tone already in the work area. An incompletely mixed load from the palette can therefore be completed in the wake of the blending brush.

CLEANING UP
Clean up as usual by removing brush marks and correcting errors.

Mix light yellow gray.

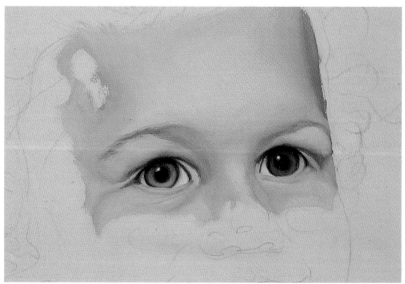

Finish the whites of the eyes.

Nose: The Nostril Interiors

The nostril interiors are the darkest point of the nose but not quite as dark as the pupils of the eyes. Actually, they appear more the color of the deep creases of the lid lines: yellow brown.

MIXING

Mix yellow brown by mixing yellow black first and then tinting it as before.

Color	B	R	Y	W
Yellow black	■	□	▦	
Yellow brown	▦	□	▦	
To mix yellow brown from yellow black, add:*		▦	▦	

<div style="text-align:center">THE KEY TO THE SYMBOLS IS GIVEN ON PAGE 20</div>

*Add more yellow than red, to avoid mixing red brown.

We now use a new palette to help demonstrate that the process of mixing colors follows the same logic in every work area. Yellow brown is the darkest tone in this work area, but we still mix yellow black first and mix yellow brown from it.

LOADING THE BRUSH

Load the no. 1 round brush—or the no. 3 if your painting is larger than mine—and shape the brush hairs to a point.

STROKING ON THE PAINT

Fill in the nostril interiors, working carefully because these are small areas.

BLENDING

Blending is not necessary in these first steps because no other tones are present.

CLEANING UP

Cleaning up at this point is confined to the wiping of the brush to straighten the hair, since we have only one color in the work area so far.

Begin the nose area at the nostril interiors.

Mix yellow brown.

Nose: The Underside of the Nose and the Cheeks

Here we establish some of the shadows that give the nose and cheeks their character and make them seem to protrude toward the viewer.

MIXING

Mix cream orange from yellow brown.

Color	B	R	Y	W
Yellow brown	■	☐	■	
Cream orange	☐	☐	■	☐
To mix cream orange from yellow brown, add:		☐	■	☐

THE KEY TO THE SYMBOLS IS GIVEN ON PAGE 20

We also use rose orange to give the cheek shadows a rosy glow:

Color	B	R	Y	W
Cream orange	☐	☐	■	☐
Rose orange	☐	■	☐	☐
To mix rose orange from cream orange, add:*			■	☐

THE KEY TO THE SYMBOLS IS GIVEN ON PAGE 20

*Rose orange retains a reddish cast but takes on a creamy appearance because of the added white. It is not to be confused with cream orange, which is decidedly more yellow.

LOADING THE BRUSH

Load cream orange onto the no. 1 or no. 3 round liner brush and shape it flat.

STROKING ON THE PAINT

Stroke the load of cream orange onto the canvas, beginning at the nostril interiors. Continue along the underside of the nose, around the nose tip, over each nostril opening, around each nostril flare, and only partially along the sides of the nose.

Find the cheek lines that begin behind the flares of the nostrils and end at the mouth corners. These cheek lines establish the width of the nose at the nostrils, as well as the width and character of the mouth. Connect the mouth corners along the edge of the upper lip, thus surrounding the light area above.

Spread rose orange outward along the cheek lines to form a shadow under the expanse of the cheeks. These are valuable contours in the rendering of the large, featureless surfaces of the cheeks. This redness will enhance the appearance of the cheeks later.

BLENDING

Blend where cream orange touches the yellow brown of the nostril interiors.

CLEANING UP

Take more notice now of cleaning up the area before continuing, since more tones are on the canvas. Don't leave strokes unblended. Wipe the brush before continuing.

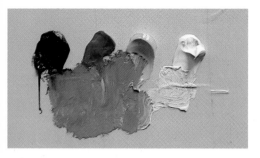

Mix cream orange.

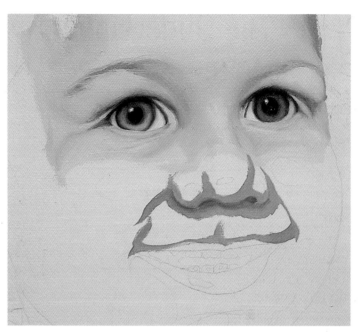

Continue with the underside of the nose, then the cheek lines from the nostrils down to the mouth corners. Connect the mouth corners along the top edge of the upper lip.

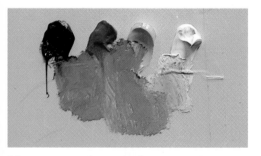

Mix rose orange, the area under the yellow in this palette photo.

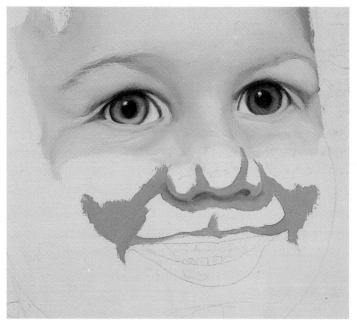

Use rose orange under the cheeks.

Nose: Blocking in the Lighter Tones

By the end of this step, the nose and cheeks will have a convincing three-dimensional structure of light and dark values, but their complexion will be too dark. Again, we will adjust the skin tones later.

MIXING
Mix cream white from cream orange.

Color	B	R	Y	W
Cream orange	☐	☐	▨	☐
Cream white	◆	◆	☐	■
To mix cream white from cream orange, add:			☐	■

THE KEY TO THE SYMBOLS IS GIVEN ON PAGE 20

LOADING THE BRUSH
Load cream white onto your no. 1 or no. 3 round liner brush and shape it flat to "sweep" broader areas at a time.

STROKING ON THE PAINT
Surround and connect paint islands. Just as in the eyes area, this will isolate the remaining pools of unpainted canvas, which represent the lightest areas of the skin according to the original photograph.

Begin below the nose at its outline. Stroke first to one side and then to the other around the flaring nostrils, taking in the passage where the cheek lines merge with the nose behind the nostrils. Venture up along the sides of the nose and then away from it below the lower eyelids and on top of the cheeks. Stroke further outward around the central protruding area of each cheek.

Now join the cheeks with the eye area around the side of the face at the temples, below the lower lids, and along the sides of the nose. Here the cheek lines join the nose behind the nostrils and fan upward into the eye corners on either side of the nose, giving the nose bridge its distinctive width. This is especially noticeable when there is slight foreshortening, as in the right side of this particular portrait.

Stroke cream white under the nose, along the crest of the upper lip, and along the inside of the cheek lines, effectively hemming in a light "mustache" area on either side. Surround the light areas on the nose itself: on the nose tip, on each of the nostrils, and at the top of the nose between the eyes. (To ensure a smooth continuation of complexion and shape, we must paint a bit over our previous work in the eyes area.) Leave smaller islands of unpainted canvas where the skin is especially well lighted and requires a lighter color.

BLENDING
Blend cream white with the tones already on the canvas.

CLEANING UP
As always, remove brush marks and wipe the brush. Remember, as the work area becomes more saturated with paint, the potential for error is greater.

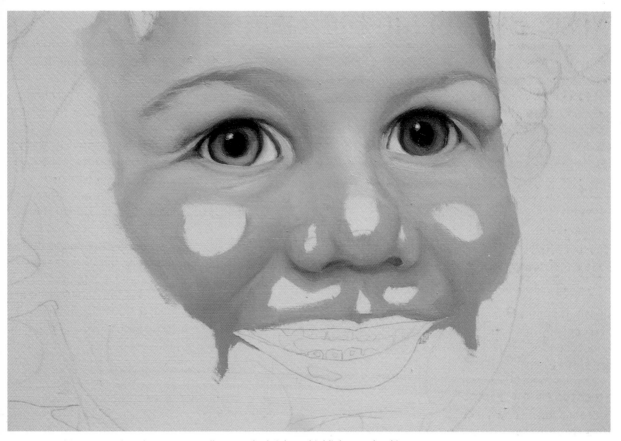

Use cream white to complete the nose area, all except the brightest highlights on the skin.

Mix cream white (the lower left area of this palette).

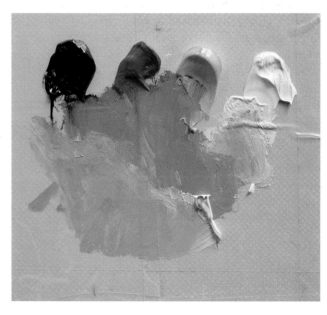

Nose: Finishing the Nose Area Realistically

In painting the shadows of the nose area in tones dominated by yellow, as prescribed for a light complexion, we have defined the lightest areas in the form of canvas left clear of paint. They represent the light, glowing areas of the photograph, and we will now fill them in with the contrasting pink tone of rose white to finish the nose area.

MIXING

Mix rose white from white, red, and a little cream white as before:

Color	B	R	Y	W
Rose white	♦	☐	♦	■

THE KEY TO THE SYMBOLS IS GIVEN ON PAGE 20

LOADING THE BRUSH

Load rose white onto your brush. If you have been using a no. 1 brush so far, switch to the no. 3 for the nose; if you have been using the no. 3, continue with it. Either way, use the no. 6 flat brush for the cheeks.

STROKING ON THE PAINT

At this point stroking is mostly blending, actually a sophisticated form of stroking. Stroke the load of paint onto the canvas at the lightest point of each light area in turn.

Remember to wipe the brush in between loadings because we are increasingly picking up stray pigment from other tones in the area. Test your version of rose white first on the cheeks. If it appears correct, do the area below the nose next, followed by the nose tip, the flaring nostrils on either side, and the ridge of the nose up to its top between the eyes area.

Where the cheeks join the nose on either side, there are key passages between the cheek lines and flaring nostrils, and between the inner eye corners and the bridge of the nose. They are light even though they are valleys instead of protruding areas. They are quite distinct and sometimes affect the width of the nose at its base and at its top. If they are not kept symmetrical, the face may look distorted.

BLENDING

Blend rose white from the center point in each light, glowing area, outward into the surrounding tones (which are probably cream white or even cream orange). Rose white will of course begin changing during blending to some average of itself and the others. This facilitates the transition between these very contrasting tones that gives us control of shape and complexion.

CLEANING UP

The cleaning routine is more involved now, beyond just removing brush marks and correcting errors. Balance the tones of the eye area and nose area until the boundary between them is invisible. They must be uniform in light versus dark contrast as well as the relative dominance of rose white versus all the yellowish tones.

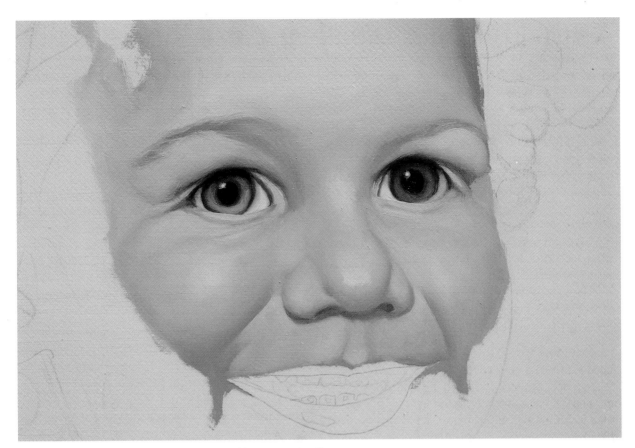

Finish the nose area by blocking rose white into the lightest areas still left blank, and blending it with the yellower tones already in place.

Mix rose white (right) by adding white to some of the rose orange already on your palette. The resulting mixture may be too yellow, so add a little fresh red. If you add too much red, however, the tone might need a touch of cream white (left).

Mouth: The Corners of the Mouth

Look at the photograph and study our next work area, the mouth. Identify the darkest tone there. Since the lips are parted, the darkest part of the mouth is inside, at its outer corners, behind the teeth. If the mouth is closed, the darkest location would still be the mouth corners, but confined to the dark line that separates the upper and lower lip. The tone needed is neither as dark as the pupils nor as yellow as the nostril interiors. Red brown is the best color to paint this, even though it is usually designated for a darker complexion. The many blood vessels in the mouth make it the reddest part of the face.

Note that if the subject's mouth is closed in your photograph, you may not need red brown for the mouth corners at all. In that case you can proceed directly to the next step.

MIXING

Begin by mixing red brown from yellow black:

Color	B	R	Y	W
Yellow black	■	□	▨	
Red brown	▨	▨	□	
To mix red brown from yellow black, add:			▨	□

THE KEY TO THE SYMBOLS IS GIVEN ON PAGE 20

Or you can mix red brown from yellow brown:

Color	B	R	Y	W
Yellow brown	▨	□	▨	
Red brown	▨	▨	□	
To mix red brown from yellow brown, add:*	□	▨		

THE KEY TO THE SYMBOLS IS GIVEN ON PAGE 20

*If too much blue and yellow are present, the tone will appear green; fix this by adding a little red. If too much blue and red are present, the tone will appear a dark purple; fix this by adding a little yellow. Be safe and add adjusting tones in small increments.

LOADING THE BRUSH

Load the no. 3 round brush and shape the hairs into a point for a confined area.

STROKING ON THE PAINT

Stroke the load of red brown into the correct location inside the mouth at the corners. Not much paint is required since only a small area is covered.

BLENDING

No blending is involved in this step because red brown is the first color in this work area.

CLEANING UP

Clean up as usual by wiping the brush.

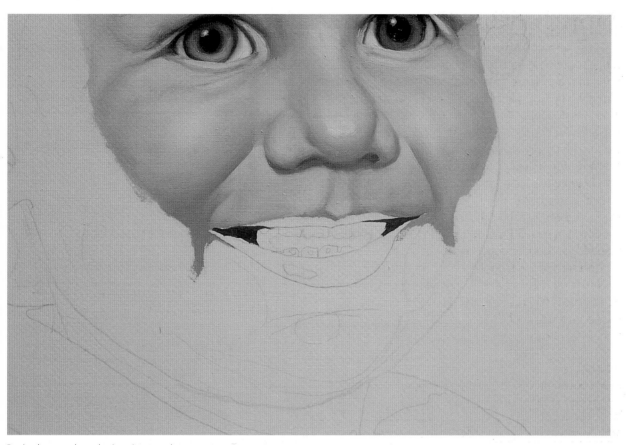

Begin the mouth at the interior mouth corners.

Mix red brown.

Mouth: The Lips

This step involves fine detail work with several colors.

MIXING

Begin by mixing rose orange from red brown:

Color	B	R	Y	W
Red brown	■	■	☐	
Rose orange	☐	■	☐	☐
To mix rose orange from red brown, add:*		■	☐	☐

THE KEY TO THE SYMBOLS IS GIVEN ON PAGE 20

*Rose orange retains a reddish cast but takes on a creamy appearance because of the added white. It is not to be confused with cream orange, which is decidedly more yellow.

We will also need some cream orange and cream white for stroking in skin tone still lacking below the mouth. Mix them as follows:

Color	B	R	Y	W
Red brown	■	■	☐	
Cream orange	☐	☐	■	☐
To mix cream orange from red brown, add:			☐	☐

THE KEY TO THE SYMBOLS IS GIVEN ON PAGE 20

Then mix some cream white from part of the cream orange on your palette:

Color	B	R	Y	W
Cream orange	☐	☐	■	☐
Cream white	◆	◆	☐	■
To mix cream white from cream orange, add:			☐	■

THE KEY TO THE SYMBOLS IS GIVEN ON PAGE 20

Finally, we will need rose white. Mix it as before from white, red, and a bit of cream orange:

Color	B	R	Y	W
Rose white	◆	☐	◆	■

THE KEY TO THE SYMBOLS IS GIVEN ON PAGE 20

LOADING THE BRUSH

Load the appropriate tone when needed using the no. 3 round brush, shaped flat.

STROKING ON THE PAINT

Start at one mouth corner and paint rose orange below the upper teeth, then above the lower teeth. Also extend the mouth corners further toward the center of the mouth, thus in effect isolating the teeth and the lighter central area of the tongue. (If the mouth is closed in your photograph, connect the mouth corners along the line where the upper and lower lips come together.)

Then, starting again from the mouth corners, follow both the upper and lower edges of the lips. The bottom edge of the upper lip runs across the gums and the roots of the upper teeth, while the inner edge of the lower lip runs across the crowns of the lower teeth. (A smile pulls the upper lip higher but does not pull the lower lip much lower.)

The outer edge of the lips surrounds the mouth and blends with the yellowish skin tones beyond. For this purpose, wipe the brush and stroke cream orange around the edge of the mouth wherever it is lacking. During this process of completing the lips, isolate the highlighted areas of the lips and bring out their shiny, convex surface with rose white.

If the gums are visible, complete them as little triangles wedging between the upper teeth at their roots. Do not, however, paint lines between the teeth. Invariably they will appear too dark and too wide. (This particular demonstration is a little deceptive because the boy's baby teeth are in fact separate enough that we can glimpse the tongue between them. Later demonstrations will give a better example of how to create the illusion of individual teeth by using yellow gray and light yellow gray.)

BLENDING

Blend around the edge of the mouth where rose orange meets yellowish skin tone. The blending along these edges will soften the lips and make them appear part of the face. Continue with cream white to establish some of the lighter areas around the mouth, such as below the mouth corners.

CLEANING UP

Special attention is needed in this step to avoid error because we change tones often. Wipe the brush between changing tones.

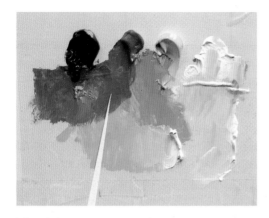

Mix a dark rose orange.

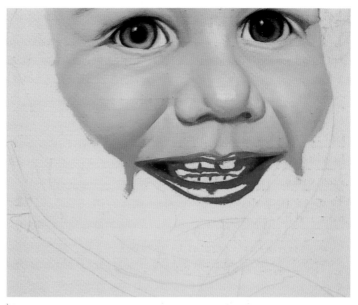

Starting at the corners of the mouth, outline the inner and outer edges of the lips and surround the light central area of the tongue.

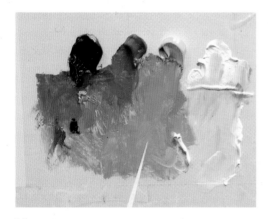

Mix cream orange.

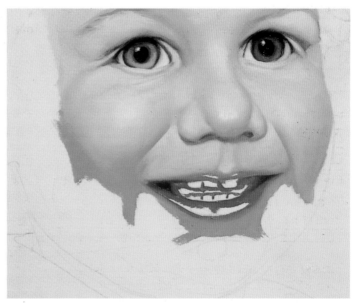

Begin the skin shadow around the lips.

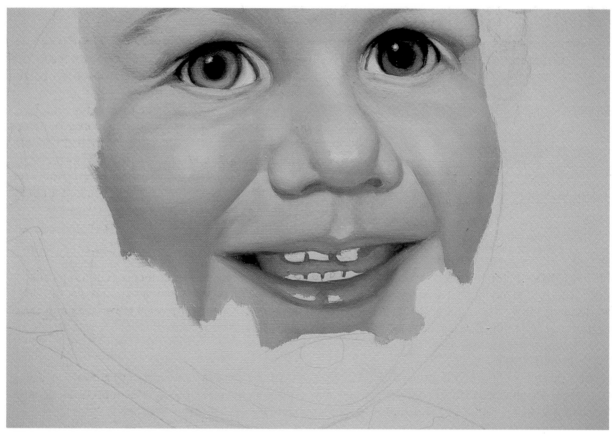

Continue skin tone around the lips with cream white, and
fill in more of the lips' surface with dark rose white.

Mix cream white (left)
and dark rose white.

Mouth: Beginning the Teeth

We will begin the teeth with the same color we used to begin the whites of the eyes: yellow gray.

MIXING
Mix yellow gray as before.

Color	B	R	Y	W
Yellow black	■	□	▨	
Yellow gray	▨	□	▨	□
To mix yellow gray from yellow black, add:			□	□

THE KEY TO THE SYMBOLS IS GIVEN ON PAGE 20

LOADING THE BRUSH
Load the no. 1 round brush (or no. 3 if you are working on a large canvas) and shape its hairs into a point for the confined area of the teeth.

STROKING ON THE PAINT
Begin the teeth by stroking in yellow gray, which represents shading around the edge of each tooth to make it appear round. The teeth appear darker as the upper and lower rows recede into the mouth corners. This is similar to the way the whites of the eyes recede into the corners.

Work each tooth individually, but do them in corresponding pairs, starting in both mouth corners and working forward along the row of teeth. Make the yellow gray outline less substantial as the lighter teeth are encountered further forward in the mouth, until the two top front and two bottom front teeth are reached. This leaves more room for lighter tones to finish each tooth later.

BLENDING
Blend where yellow gray meets gum or lip color, especially in the outer corners of the mouth. The highlight of each tooth is left clear for lighter tone to follow.

CLEANING UP
Wipe the brush and correct errors. Avoid smearing red from the surrounding area onto the teeth, or it will look like smudged lipstick!

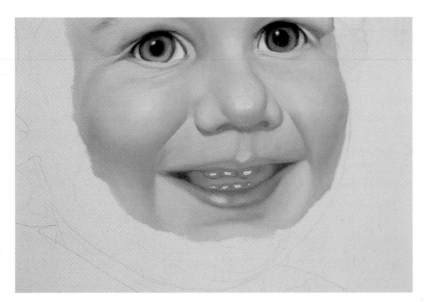

Begin the teeth. They will look too dark at first, but remember, these are just the shadows. Use rose white to refine the blending of the lower lip.

Mix yellow gray (left) and rose white.

Mouth: Finishing the Teeth

Much of the whiteness of the teeth seemed to disappear as they were filled in with yellow gray, but it will be quickly reestablished. Remember that the artist creates the illusion of shape by playing dark tones against light tones. Lighter tones appear to emerge from the canvas, while darker tones appear to recede. We are about to make the teeth look both white and round.

MIXING
Mix light yellow gray as before when we painted the whites of the eyes:

Color	B	R	Y	W	
Yellow gray	■	☐	■	☐	
Light yellow gray		☐	◆	☐	■
To mix light yellow gray from yellow gray, add:					■

<div align="center">THE KEY TO THE SYMBOLS IS GIVEN ON PAGE 20</div>

We will also need a little rose white, mixed a few steps earlier, to finish the highlights on the lips.

LOADING THE BRUSH
Load the no. 1 or no. 3 round brush with the appropriate tone and shape it into a point.

STROKING ON THE PAINT
Fill in the remainder of unpainted canvas on each tooth with light yellow gray to establish its degree of brilliance, and touch the remainder of each tooth lightly. Remember that not all teeth are the same shape, so paint what you actually see.

Take special note of each tooth's orientation—that is, the degree to which each tooth turns its front side away from you as its position in the row of teeth changes toward the rear of the mouth. A highlight on each tooth indicates this orientation because it shows what part of each tooth's curved surface is closest to you. That location will vary, for example, from a centered location on the two front teeth facing you directly when the pose of the subject is straight on, to an increasingly off-center

location for the teeth further back toward the mouth corners. Keep in mind that if the subject's head turns more to one side, the highlights move, and those on the front teeth may no longer be centered, whereas others toward the exposed corner of the mouth may be centered instead.

BLENDING
Blend the little daubs of light yellow gray carefully into the surrounding darker yellow gray tone without overpowering it. Very slight adjustments in this balance of light versus dark tone can have a dramatic effect for each tooth. Teeth contribute considerably to the character of a face. Finishing of the teeth removes any doubt about their roundness at the edges and establishes their realistic appearance.

The brightest highlight on each tooth is now rendered with almost pure white to give the teeth a moist appearance, further increasing their realistic appearance. Remember that the upper lip casts a shadow over the upper portion of the upper teeth, but their lower portion is brightly illuminated.

At the lightest point of the convex areas of the lips, blend rose white slightly into the surrounding lip tones to add an accurate degree of roundness and moisture.

The gaps between the teeth should be the inadvertent remainder of light yellow gray's blending effect over the yellow gray shadow tones of each tooth. They should be a subtle hint only. Avoid painting these gaps directly, as explained earlier, or they will invariably appear too wide.

CLEANING UP
Remove brush marks and correct errors—not just on the teeth, but on the entire mouth area—before we go on to the next work area. As at the end of earlier work areas, we must balance the contrast and complexion for the current area (the mouth) and then integrate it with the nose area and eyes area. This ensures consistency and no visible "lines of demarcation" between work areas.

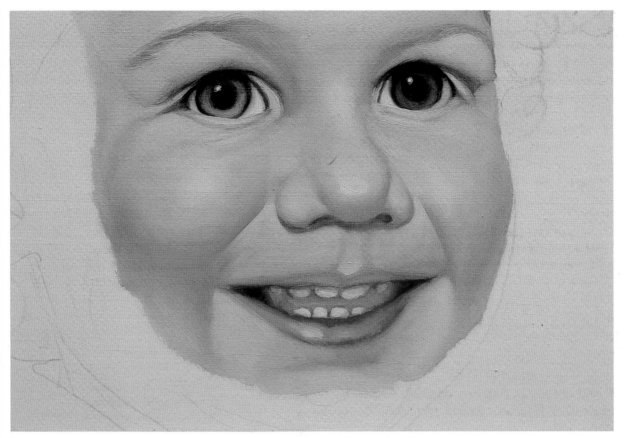

Finish the teeth and the mouth area.

Mix light yellow gray.

Jaw Area: Beginning the Background

Surround the outline of the head behind the jaw, neck, and ear. The idea here is to bring wet paint (of approximately the correct color) right up to all the edges of the face, so that in the next two steps we can blend the skin tones of the jaw and neck slightly with the background for a natural-looking edge. This process is not quite finished until the next step, but you can see most of it here.

In this portrait a background tone is stroked up to the edge of the face, and hair tone is stroked around the ear. Corrections to the facial outline can now be made if the original pencil lines are not quite correct or no longer visible.

MIXING

Use a new palette prepared with the four basic colors. First mix yellow black:

Color	B	R	Y	W
Yellow black	■	☐	▨	

THE KEY TO THE SYMBOLS IS GIVEN ON PAGE 20

Then mix yellow brown from yellow black for the deep shadows of the hair close to the face:

Color	B	R	Y	W
Yellow black	■	☐	▨	
Yellow brown	▨	☐	▨	
To mix yellow brown from yellow black, add:*			▨	▨

THE KEY TO THE SYMBOLS IS GIVEN ON PAGE 20

*Add more yellow than red, to avoid mixing red brown.

In this case I will also mix a light greenish blue for the background and the collar of the boy's sweater, and a light lavender for his shirt. I like background colors from the blue family because they fall outside the range of skin tones and offer a pleasing contrast.

If you are painting your own subject rather than mine, use whatever tones your photo calls for, or make up your own to suit your taste. With clothing and background colors you are free to be creative, so have some fun.

LOADING THE BRUSH

Load the tone you need onto your no. 6 flat brush. This brush allows heavier deposits of paint and more rapid progress across larger areas than the two round brushes do. Remember to wipe the brush before reloading, especially when changing tone.

STROKING ON THE PAINT

With plenty of yellow brown on your brush, stroke in paint behind the ear, in the deep shadows of the hair just beyond the hairline on both sides of the face. Cover a band of color only about an inch wide; for now leave the rest of the hairline above the forehead until later because we are not yet painting the hair itself. Do cover these side areas of yellow brown thoroughly so that no canvas shows through. It is possible that in your photo the yellow brown should outline the face more extensively; if your subject has long hair, for example, yellow brown should go behind the neck as well.

BLENDING

The only blending that occurs in this step of my painting is in the colors of the clothing.

CLEANING

Cleaning up at this point is confined to wiping off the brush.

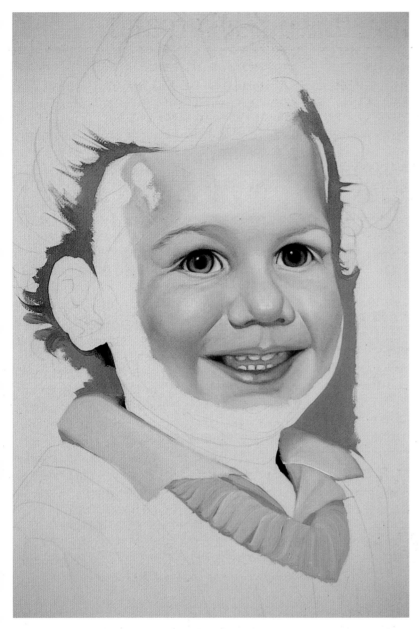

Begin the background
beyond the jawline.

Here are yellow
brown (right) and
two tones used in
the background
and clothing.

Jaw: Beginning the Jawline, Ear, and Temple

Now that we have a wet area on the canvas beside the head, the tone we now use to begin the jaw can be stroked up to these background tones and slightly blended. This first tone along the jaw becomes a buffer to prevent the rest of the lighter tones from spilling into the background, and vice versa.

MIXING

Mix a dark cream orange from yellow brown as before:

Color	B	R	Y	W
Yellow brown	■	☐	■	
Cream orange	☐	☐	■	☐
To mix cream orange from yellow brown, add:		☐	■	☐

THE KEY TO THE SYMBOLS IS GIVEN ON PAGE 20

LOADING THE BRUSH

Load cream orange onto your no. 6 flat brush.

STROKING ON THE PAINT

The jawline and the edge of the face must blend slightly wherever they meet the background and clothing area painted in the preceding step. With the brush wiped and uniformly loaded with cream orange, stroke in the narrow shadow where the neck disappears into the shirt, as well as the shadow under the jaw. Also take the opportunity to stroke the tone into the folds of the ear, especially at the entrance to the ear canal.

Stroke a slightly lighter cream orange (add some white) in the face along the jawline. Begin at the temple and continue around the outer edge of the ear, the earlobe, and then along the jaw, around the chin, and up past the cheek and temple. Brush this tone deep into the hairline at the sides of the forehead. On one side of the face, the background is visibly outlining the edge because of the way the head is turned in this pose. Stroke in a heavy but narrow band of cream orange that precisely outlines the face.

BLENDING

Blending is important in this step wherever cream orange touches the background tones. We want to leave a softened edge on the sides of the head, as we will later do around all of it. This prevents the head from looking as if it were cut out and pasted onto the background.

CLEANING UP

Take more notice now of cleaning up the area before continuing; don't leave strokes unblended. Wipe the brush.

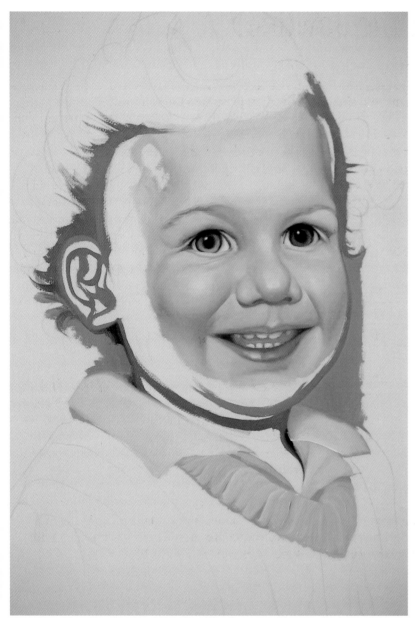

Begin the jaw and ear at their edge.

Mix cream orange.

Jaw: Completing the Jaw Area

By the end of this step, the jaw area should have a definite structure, but the overall complexion of the jaw work area should look quite dark and yellow. These shadow tones will be blended more as the last tone follows. At this stage we rely on stroking to sculpt the structure of the features and blending to remove roughness.

MIXING

Mix cream white by tinting cream orange, just as before:

Color	B	R	Y	W
Cream orange	☐	☐	▓	☐
Cream white	♦	♦	☐	■
To mix cream white from cream orange, add:			☐	■

THE KEY TO THE SYMBOLS IS GIVEN ON PAGE 20

LOADING THE BRUSH

Load cream white onto your no. 6 flat brush so that you can "sweep" broader areas at a time. Use a finer brush, such as a no. 1 or no. 3 round, for painting the details of the ear.

STROKING ON THE PAINT

Use cream white to connect areas of cream orange and isolate the highlights on the skin, just as you did at comparable steps in the earlier work areas. The jaw area is larger than the eyes or nose area, covering an extensive surface along the jaw from the chin up to and along the temple. In nearly any studio-quality photograph, there is a glow on the chin, on the light area flowing down from around the lower lip at the mouth corners, and in the hollow below the protuberance of the cheek. (The jaw area should be smoothly connected with the mouth area in both of these last two places.) In most studio-quality photos, there is also an overall glow from indirect lighting that falls gently along the jaw from the ear to the chin. The hills of the folds in the ear shine, as well as some of the valleys between folds.

Within the buffer zone established in the previous step, make inroads along shadow contours into the interior of the face. Connect with the shadowing of the cheek lines spilling from around the mouth corners and the shadowing under the lower lip and on top of the chin. Connect further with shadowing that underscores the cheeks.

The ear is composed of sharp contours that curl and twist in different directions. Start with the darkest point at the entrance to the ear, and follow the contour out. A thin shadow line is needed around the inner rim of the ear to merge with the outside rim painted earlier.

BLENDING

Make sure that cream white blends into the old tones around the mouth and the cheek. Blend this new tone with all previous tones wherever they meet. Blending becomes more important as more tones overlap in the same work area. Make your brushstrokes disappear and sculpt shape by the degree to which the new tone is pushed into the others. Balance the contrast between light and shadow areas. It may require adding more light here or a little shadow color there, and blending.

As said before, distinctions between tones are initially sharp during stroking of the load along an old tone. Blending lessens these distinctions to a point where the smooth transition of tone translates into realistic shape. If overdone, however, the tones become overmixed, with a corresponding loss of distinguishable shape.

CLEANING UP

Once again, as the work area becomes more saturated with paint, the potential for error becomes more likely. Remove brush marks and wipe the brush.

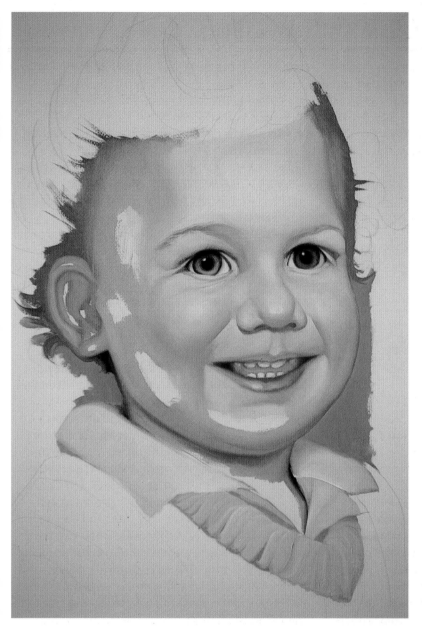

Use cream white to complete the jaw area, all except for the brightest highlights of the skin.

Mix cream white.

Face: Finishing Up

In this step we will finish the jaw area with realistic skin tones. This is also the time to study your photograph closely and make whatever improvements are needed to give your portrait a truer likeness and a more realistic finish.

MIXING
You will need rose white to finish the jaw area. Mix it as before from white, red, and a touch of cream white:

Color	B	R	Y	W
Rose white	◆	☐	◆	■

THE KEY TO THE SYMBOLS IS GIVEN ON PAGE 20

Also mix whatever other colors you need for adjustments elsewhere on the face.

LOADING THE BRUSH
Load rose white onto your no. 6 flat brush.

STROKING ON THE PAINT
We have now achieved a realistic shape across the face with the remaining highlight areas of the skin very well defined. However, the realistic complexion in the jaw area and uniformity of skin tone across the whole face are still lacking. Just as we did in earlier work areas, we will now use rose white to contrast with the yellow tones and create a realistic light complexion. We will also complete the forehead from the eyebrows up to the hairline.

Stroke rose white onto the lightest point of each light area in turn. Remember to wipe the brush between loadings because we are increasingly picking up stray pigment from other tones in the area.

Complete the side of the forehead by filling it in.

BLENDING
Blend the rose white outward from the center points of each highlight area into the surrounding tones as we have done before.

Refer to the similar last stage of each previous work area, and retouch the whole face with the appropriate tone. Sharpen or dull edges, lighten or darken surfaces, and enhance pinpoint highlights such as those in the forehead, below the eyebrows, the lower eyelids, the eye corners, the cheeks, behind the nostrils, the tip of the nose and chin, and the neck.

Review the final step of each work area and make sure the complexion is consistent throughout the face. If you have joined each work area with adjoining areas at the time, there should be no problem. If the paint is still wet, you can blend to fix any imperfections. If it is dry, you may need to backtrack and redo some of the steps.

Beware of excess perfectionism at this stage. The idea is to add finishing touches, not to redo the whole portrait. There are times when it is better to live with a small imperfection than to risk ruining something else by trying to correct it.

CLEANING UP
Cleaning up here is a integral part of this finalizing process. This is your last chance to clean any aspects of the face that do not satisfy you. Remove brush marks and blemishes, correct any remaining errors, and wipe your brush carefully between tone changes.

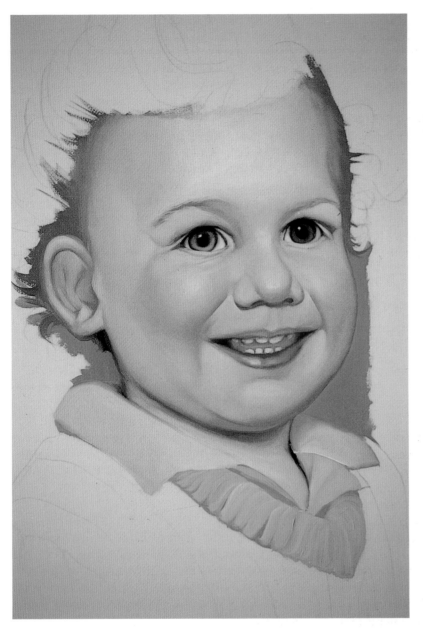

Use rose white to finish the face realistically.

Mix rose white.

Hair: The Hairline

In this step we will build up layers of strokes that leave the appearance of hair. This wet-on-wet painting process allows for an average of several tones to come into play: a deliberately darker, well-blended undertone, followed by several successively lighter tones stroked on with a fanned brush to create a remarkable resemblance to actual strands of hair.

MIXING

Mix yellow black if you have none on your palette, and then mix yellow brown from it:

Color	B	R	Y	W
Yellow black	■	□	▨	
Yellow brown	▨	□	▨	
To mix yellow brown from yellow black, add:*			▨	▨

THE KEY TO THE SYMBOLS IS GIVEN ON PAGE 20

*Add more yellow than red, to avoid mixing red brown.

Now mix cream orange from some of the yellow brown:

Color	B	R	Y	W
Yellow brown	▨	□	▨	
Cream orange	□	□	▨	□
To mix cream orange from yellow brown, add:	□	▨	□	

THE KEY TO THE SYMBOLS IS GIVEN ON PAGE 20

The yellow brown will be used for hair shadows, so don't be dismayed if it appears considerably darker than the overall hair color. It will provide undertones over which lighter tones will be stroked, starting with cream orange.

LOADING THE BRUSH

Load the no. 6 flat brush for stroking in large areas. When you begin to stroke in actual strands of hair, use the no. 3 round brush, shaped in a fan. This is done by bearing down lightly on the end of the brush and bending the hair while bringing the handle upright. To increase or maintain a certain spread of the fan, this manipulation may have to be repeated on the canvas. Getting strokes that really look like hair takes practice.

STROKING ON THE PAINT

Stroke a hairline buffer into place across the forehead to assist the transformation of skin tone from the face into hair color. The buffer consists of typical skin shadow tones. Yellow black continues where it left off behind the ear a few steps back. Yellow brown then takes over at about the temples on either side, quickly changing to cream orange as both directions converge to the center of the hairline. These tones are smoothly blended with one another.

To stroke hair strands across the forehead, fan the brush, moistening it with a little paint the same color as the buffer zone, and set it down somewhere on the scalp. Then pull it lightly, crossing through the wet buffer area and onto the forehead, leaving such gentle curls and wisps as needed in the wake of the brush as it lifts off the canvas. The previously smoothly blended area is broken up into a texture that resembles hair. Work from the center of the forehead, aligning overlapping fanned strokes in both directions toward the sides of the head.

Do not be concerned with the irregular brush marks above the hairline where the fanned brush touches down on the canvas. These stroke beginnings will be covered up by subsequent layers of hair strokes as we come to them. Do pay attention, however, to the path created by the middle of each stroke and how the brush lifts off the forehead at the end of the stroke. These details may well remain visible later. (Refer back to page 25 for a lengthier discussion of stroking the paint onto the canvas.)

BLENDING

As you paint the buffer zone, blend the hairline where yellow brown and cream orange meet the skin tone of the forehead. Hairlike strokes require a different kind of blending of a new tone with an undertone in a way that leaves an impression of hair strands behind. Hair strokes are single strokes of the fanned brush in one downward direction with repeated overlapping of previous strokes. Strokes will still blend and partially cover one another, but those on top will remain visible in the

finished painting. The wet undertone, in effect, grabs hold of the hairlike strokes and allows their ends to fade uniformly away as you let the brush ascend off the canvas like a plane takeoff from a runway. This is quite a different technique from painting skin.

It also means that errors are more difficult to correct. Before painting a hairlike stroke over wet undertones, you must anticipate what tone will result in the wake of the brush. With a little test at first, you can prevent tones that are either too green or too purple.

CLEANING UP

Clean up as usual when you paint the buffer zone. When you paint hairlike strokes, the brush must be wiped and reloaded every time, or else the delicate strokes will be obliterated as they are overlapped.

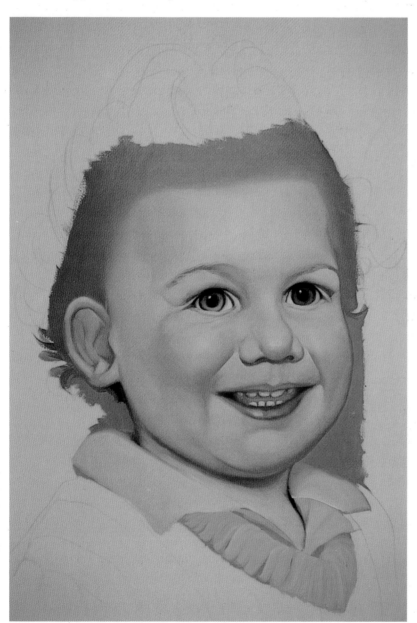

Prepare the hairline by painting a buffer zone of skin shadow tones.

Mix yellow brown (left) and cream orange.

Begin the hairlike strokes by shaping your brush into a fan, setting it down somewhere in the scalp area, and pulling it lightly through the buffer zone toward the forehead.

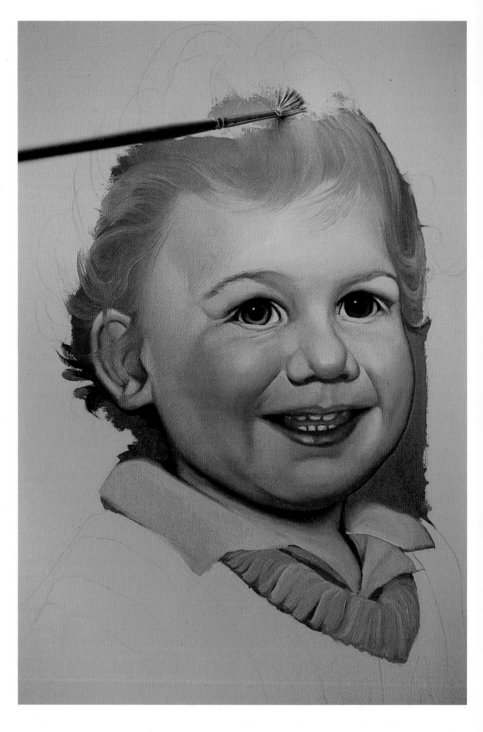

Hair: Finishing Up

As you paint the hair, remember that the hair paths should flow along the contours suggested in the photograph to resemble both the hairstyle and the shape of the head. The ends of the hair strokes may occasionally have a sharp curl as the brush leaves the surface. Do not pass your brush over the same path without wiping and reloading it, or else blending occurs and fine hair texture disappears.

MIXING

A little linseed oil mixed with the lighter tones for the hairlike strokes allows you to brush unbroken strokes smoothly. However, use the linseed oil sparingly because it makes the paint transparent. To apply the oil in the mixing pool on your palette, pour a few drops of oil into a bottle cap. Wipe the brush and dip it into the oil, letting only the very tip of the brush moisten slightly. Any more oil than that is too much. A little oil is good for three or four loads of paint.

Mix yellow black, yellow brown, cream orange, and cream white, and background color as needed.

Color	B	R	Y	W
Cream orange	☐	☐	▨	☐
Cream white	◆	◆	☐	■
To mix cream white from cream orange, add:			☐	■

THE KEY TO THE SYMBOLS IS GIVEN ON PAGE 20

The tones will vary in this step, becoming lighter until the overlapping layers of hair strokes reach the top layer of hair and then become darker again where the hair recedes into shadow toward the crown and back of the head.

The tone sequence is much the same as the skin tone thus far. The first three tones—yellow black, yellow brown, and yellow orange—were already begun and will be the two tones ending in reverse order at the crown of the head. Up to this point the choice of tones is the same for any color of hair. The main problems have already been overcome: the transition from skin tone at the forehead to hair color at the hairline, and then the subsequent creation of a hairlike texture.

It is the intervening lighter tones that give hair

color to the head in the next layers of hair strokes before reversing darker again to the crown. It is here that you have maximum control over hair color.

Remember that all colors of hair use the same undertones blended from yellow black, yellow brown, and cream orange. Using more of one tone than another will create a dramatic difference in the perceived hair color. Though this demonstration shows only one hair color, I will refer to others briefly. Brown hair uses yellow black and yellow brown for dark areas, with cream orange, cream white, and even rose white for highlights. Red hair uses yellow brown and cream white, with an emphasis on cream orange; all these tones are decidedly yellow. Blond hair emphasizes the yellower skin tones such as yellow brown and cream orange, and rose white is replaced with cream white for its obviously yellow content. For blond hair, a slight greenish cast may appear as you stroke lighter tones over the darker yellow brown and yellow black undertones; this is acceptable.

LOADING THE BRUSH

Continue with the no. 3 brush and load cream orange first and later cream white.

STROKING ON THE PAINT

Stroke the brushload and begin the hair stroke layering process as before at the sides of the head and proceed alternately toward the middle of the head above the forehead. Let the ends of this layer, like subsequent layers, overlap the beginnings of previous layers. The ends of this layer must "weave" almost imperceptibly with the stroke middles of the preceding layers.

Now that the entire hair area is covered with wet paint, brush a wide band of whatever background color you choose all around the hair's edge. Gently brush along the common edge of wet background and hair, and let the brush drag along a little of both to leave a soft union in its wake. The odd unruly wisp of hair strand floating over the background in several places can be stroked over the forehead with single light and lengthy strokes.

Repeat the process of hairlike strokes until you reach the layer where the glow on the hair is most intense. Add more strokes carefully and in reverse order—becoming darker to reestablish shadows in the hair that may have become covered up with the light tones. For this process, switch from cream white to cream orange, then yellow brown, and finally yellow black if needed behind the ear.

The tricky part of doing hairlike strokes is that you try not to repeat a stroke once it is made, because the second stroke will obliterate the first. In building up layers of hair, we do brush over previous strokes, but the difference is that the successive layers are progressively lighter in tone. Though they affect the strokes below, they also let them show through in select places, thus capturing the effect of light and shadow and making the hair look surprisingly realistic.

It is assumed that you are using the brush handling techniques already discussed and wiping the brush after every stroke. Hair requires much practice, but it is an established technique like everything else in this book and can be learned.

Rendering hair in paint strokes is a matter of making the middle of each brushstroke consistent with the direction of the corresponding hair in the photograph. To paint straight hair, overlap many similarly performed hairlike strokes sideways. Curly hair does not require this kind of precise stroking; it is done with many tightly curled hairlike strokes performed with a quick flick and twist of the brush.

The strokes can be long or short, tightly or loosely curled, or sweeping in waves. In long, straight hair, for example, it is common to begin a stroke at the crown of the head and pull one continuous stroke alongside the head over the shoulder and beyond for a long lock of hair. Pressing down on the brush helps lengthen the stroke in such cases. With practice, it is also possible to land a new stroke very carefully in the middle of a previous stroke so that its beginning is invisible.

Finish the hair by stroking light, almost white strands of fine, wispy hair. When stroking the final layer, place the brush at the crown of the head and pull the stroke forward. Once the path covers the origin of a previous stroke, start to lift the brush off the surface to leave a soft texture suggesting hair ends. The stroke path should not travel too far down toward the forehead and disturb realistic-looking hair strands already in place.

To cover the beginnings of the final layer of strokes, start them all in the same place on the crown of the head, and then carefully blend that place only. With curly hair, middles and ends of strokes can cover the beginnings even of the last layer. If the subject has a part, start the final layer at the front of the head and work backward so that each new stroke covers the beginning of the preceding one. Then blend the beginnings of the very last strokes, at the back of the head, with the background.

BLENDING

The hair strokes automatically blend with one another as they overlap, but the top stroke always remains distinct. Deliberate blending is limited to the outer edge of the head.

CLEANING UP

Clean up as usual.

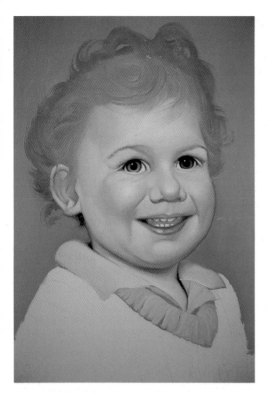

Continue with layers of hairlike strokes and complete the headline at the background.

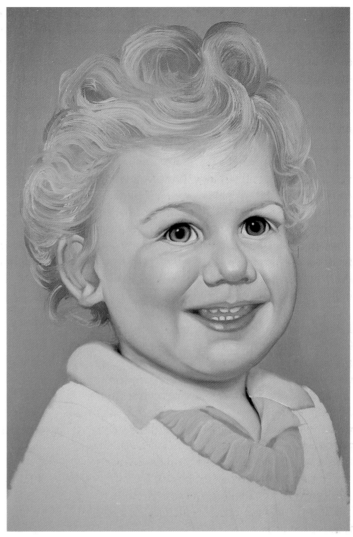

Mix cream white.

Finish the hair by stroking only the lightest strands.

The Finished Portrait

In Skill Level One, we have taken the most meticulous approach to painting a portrait. With this approach there is the least chance of error because we finish one small portion of the face before risking another. This ensures that the likeness is retained as we progress and that the desired degree of realism is achieved.

You should continue this approach until you feel comfortable in rendering all the special characteristics of the different parts of the face, and until you are able to keep a uniform complexion from one work area to the next. Pay special attention to the progress from darker to lighter skin tones and how you derive each tone from the preceding one by adding what is missing. The art of mixing colors is the art of recognizing what is missing—*how* one tone differs from another.

In the next skill level we will paint the face of a young woman as if it were a single large work area. Remember, as you go through Skill Levels Two through Four, refer back frequently to Skill Level One to see how specific parts of the face were handled there, and how colors were mixed. The more proficient you become in Skill Level One, the better prepared you will be to move on to more efficient methods of portraiture.

This is what the palette looked like when the painting was finished. You can see the variety of tones used in the hair—yellow black, yellow brown, cream orange, and cream white—as well as colors used for background and clothing.

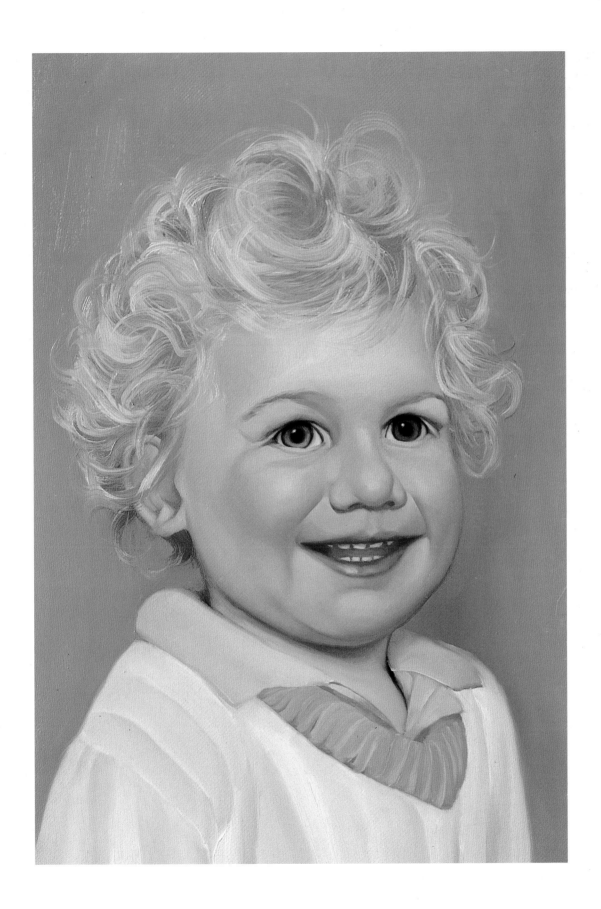

SKILL LEVEL TWO:
PORTRAIT OF A YOUNG WOMAN

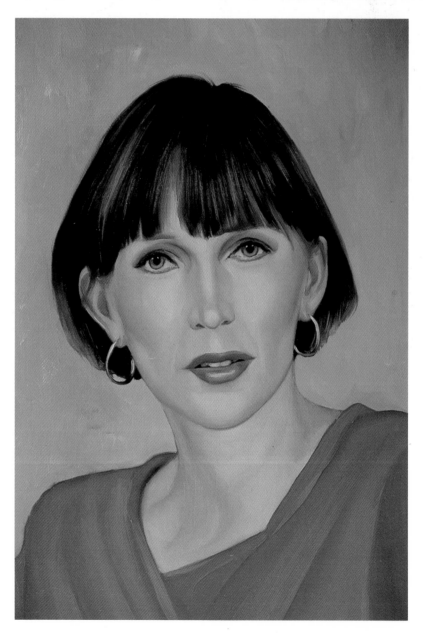

The portrait of a young woman we are about to paint in this demonstration is more difficult than the preceding one because all parts of the face and head are treated as one work area. On the palette, we progress only once from the darkest tone to the lightest, rather than starting over for eyes, nose, mouth, jaw, and hair as we did before.

There are certain advantages to reaching Skill Level Two; you can maintain an overall realistic shape and complexion as you work. However, this more advanced method requires proficiency in rendering the individual parts of the face and head.

It is assumed by now that you have learned how to mix the skin tones—or, if you need to refresh your memory, that you will refer back to a similar step in Skill Level One.

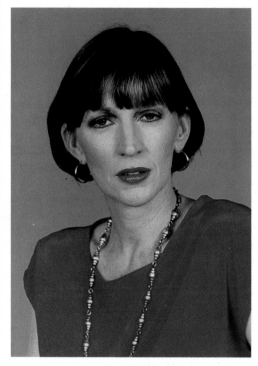
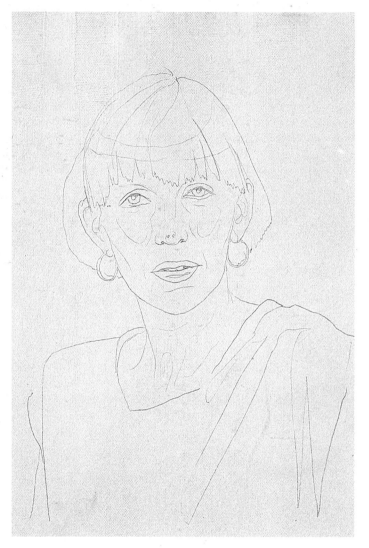

Here are the original photo and pencil drawing for the portrait in Skill Level Two.

Laying In the Darkest Tones

In the first four steps of this portrait demonstration, we will systematically replace the pencil drawing on the canvas with paint. The key is to know which tone to use where and when. Just as before, our rule of thumb is to start with the darkest tone, yellow black in this case, and stroke it along the pencil lines wherever a corresponding dark tone can be seen in the photograph.

MIXING
Mix yellow black.

LOADING THE BRUSH
Use the no. 1 or no. 3 round brush within the confines of the eye area, and the no. 6 flat brush in the hair area along the sides of the head and around the ears.

STROKING ON THE PAINT
In this demonstration, as in the previous one, we find the darkest point in the portrait and begin painting there—that is, the pupils and upper lash lines. But this time we go beyond the eye area and find other areas either in or around the face that have the same yellow black tone. So, as before, fill in each pupil but leave the highlights clear. Begin the lash lines above, into which the pupils appear to spill.

In this particular portrait, yellow black does not appear anywhere else in the face itself but is found in the dark shadows of the hair alongside the face, behind the ears. With the no. 6 flat brush, stroke in the indicated areas, and be sure to leave a crisp edge that now outlines the ears and sides of the head instead of the pencil lines it replaces.

BLENDING
No blending is required here because no other tones are yet present on the canvas.

CLEANING UP
As always, before reloading the brush with the same or a different tone, wipe the brush on a paper towel to straighten the hair and remove excess paint.

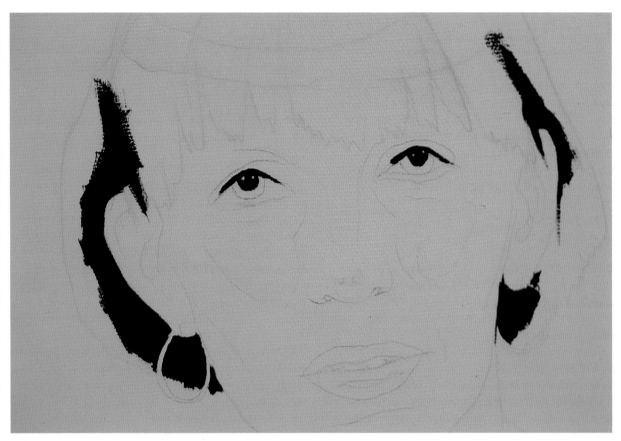

Begin the pupils, the upper lash lines, and the hair shadows beyond the ears and jawline. Paint in the hairline at the temples; this prepares for the skin tone to be stroked in the face there later.

The four basic colors—blue, red, yellow, and white—with yellow black mixed.

Creating a Buffer Zone

The next tone that follows yellow black in our color scheme for building a light complexion is yellow brown. It acts as a buffer along a narrow zone where the darkest shadow in the photograph, represented by yellow black, gives way to light areas.

MIXING
Continue the hair with yellow black. Then mix yellow brown and red brown from yellow black.

LOADING THE BRUSH
Continue using the no. 6 flat brush with yellow black in the wide area of the hair area above the forehead. In the face, however, stroke on yellow brown with the no. 3 round brush instead of the no. 1 used in the preceding step. Shape your brush flat when you load the tone off the palette.

STROKING ON THE PAINT
The preceding step concentrated on the delicate details in the eyes. The beginning of this step is simply a continuation with yellow black to cover most of the scalp as well as the hair over the forehead. This provides the wet undertone we will need later, over which lighter-toned hairlike strokes will be brushed.

Next, with yellow brown, stroke in a buffer zone along the inside edge of the face where it borders the hair—that is, across the forehead and up into and between the strands of hair now appearing as yellow black. The buffer zone also outlines the ears and the darkest fold in each. Also stroke in the thin shadow on the neck under the collar.

With red brown, begin the mouth area at the interior mouth corners. Also use red brown to continue behind the teeth and connect the mouth corners. (Remember, the abundant blood vessels in the mouth require red tones as opposed to yellow skin tones around the mouth.)

BLENDING
Blending becomes necessary now wherever yellow black and yellow brown meet. However, red brown is still isolated from any other tones, so no blending occurs in the mouth.

CLEANING UP
Wipe the brush before reloading.

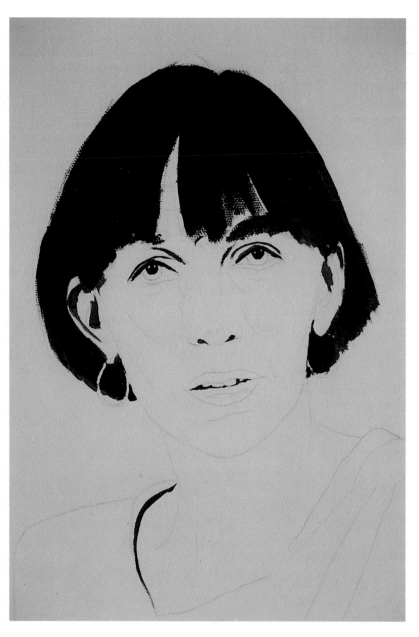

Complete the upper lash lines and begin the upper lid lines. Begin the nose area at the nostril interiors. Starting at the hairline, stroke on the yellow brown and red brown undertones for the rest of the hair. Begin the mouth at the interior mouth corners, just as you did in Demonstration One. It may also be appropriate to add any dark shadows in the clothing, as at the neckline here.

Mix yellow brown (right) and red brown (center) from yellow black (left).

Building Facial Structure

In this portrait, cream orange takes up where yellow brown left off. It is the first tone for many parts of the face, a shadow tone that provides the first painted structure across the face to replace most of the pencil lines of the drawing.

MIXING
Mix cream orange for the skin and rose orange for the lips.

LOADING THE BRUSH
Continue with the no. 3 round brush, shaped flat as before. Go ahead and clean the no. 6 brush with thinner now and set it aside until later, when you will finish the larger areas of the cheeks and forehead.

STROKING ON THE PAINT
Complete the lash and lid lines. Begin the eyebrows and give some thought to the isolation of light, glowing areas there to be finished with lighter tones still to come. The photo we used in Skill Level One did not involve eye makeup. This time, just as there, skin tones are still our basic tools for rendering the physical structure of the face and achieving a realistic complexion. Cosmetics can confuse these attempts and make the complexion appear odd, so we need to work with care.

If you find it troublesome to switch in midstream from cream orange eyelids to the bluish eye shadow tone, continue with the skin tones there and then come back and brush the cosmetic tone over it. However, you must practice switching back and forth between such startlingly different tones with ease.

Continue with the underside of the nose and then the faint indications of cheek lines around the mouth corners and around the cheekbones. Begin the jaw along its edge from temple to temple.

First stroke down around the chin and then define the shadows on the neck and its outer edge, including the collar. Continue up from the temples across the forehead and work the tone into the previous tones at the hairline.

Add lighter layers over the wet undertones from before. Continue filling in the ears, and surround the highlights on the crests of their folds.

Finally, complete the lips with rose orange, leaving a clear area for a lighter tone to follow on the lower lip.

BLENDING
Blending continues as an integral part of the stroking process. The tones should now flow together as they strike the canvas, so that applying paint and fashioning shape occur in synthesis.

CLEANING UP
Besides wiping the brush regularly, at this point we also begin correcting errors before proceeding to the next step.

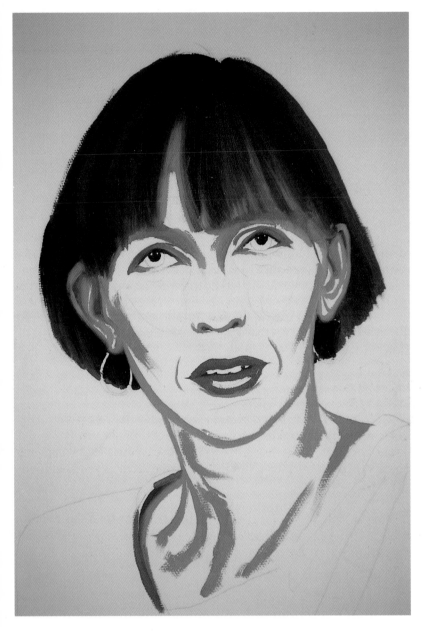

Complete the lash and lid lines and begin the eyebrows. Continue with the underside of the nose, then the cheek lines. Begin the jaw at its edge and continue the ears. Begin the hairlike strokes. Continue with lighter and darker hair layers. Complete the lips and gums with rose orange.

The left arrow shows where the bluish tone was mixed for the makeup around the eyes. The middle arrow points to a rose orange for the lips, and the arrow on the right indicates the cream orange with which the structure of the face was rendered.

Laying In the Lighter Tones

Cream white gives this face most of its bulk, building on the darker structure already prepared in the preceding step. It joins with that darker structure and surrounds pools of unpainted canvas, where a lighter tone will follow in the next step.

MIXING
Mix cream white by tinting cream orange with white.

LOADING THE BRUSH
Switch to the no. 6 brush you have already cleaned of all traces of yellow black. Put the round brushes aside.

STROKING ON THE PAINT
The emphasis throughout this step is to connect islands of shadow tones into a support structure for the face and to leave the lightest areas clear. These will be finished with rose white in the next step to create a realistic light complexion. With this in mind, complete the eyes area, the nose area, the skin tone around the lips, and the jaw area.

BLENDING
Blending is now the major part of the stroking procedure, so pay close attention to realistic shaping. Complexion is still a secondary consideration.

CLEANING UP
Before wiping the brush and going ahead to the next step, be careful to remove blemishes and correct errors. Especially in these later stages of a portrait, a little foresight really pays.

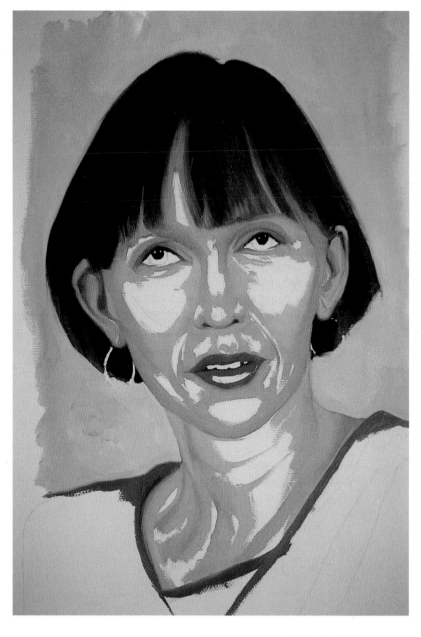

Use cream white to complete all but the highlights of the eyes area, the nose area, the skin tone around the lips, and the jaw area. Continue the hair.

Mix cream white (right) and other background colors as needed—in this case, the blue on the left.

Refining Shape and Complexion

In this step, now that the structure of the subject's face is in place, we use rose white to fill in the lightest areas from the photograph and blend them with the shadow tones. Suddenly a realistic portrait emerges.

MIXING

Mix rose white as you did in Skill Level One.

LOADING THE BRUSH

Use whatever brush size you need.

STROKING ON THE PAINT

Rose white will complete all unpainted areas of the canvas in the face and neck. The young woman in this portrait demonstration has a light complexion, which we will create by balancing and smoothly blending yellowish shadow tones and reddish light tones. Keep this in mind as you finish the face realistically: the eyes area, the nose area, the mouth area, and the jaw area. You may want to refer back to pages 26-27, where the contrast of tones on the canvas is illustrated.

Now begin each iris at the outer rim. In this case I am using blue gray since the subject of this portrait has blue eyes.

BLENDING

Blending is now a sophisticated form for stroking and is never more important than in this step to achieve realistic shape and a true complexion.

CLEANING UP

Many changes of tone may occur here between the cream and rose tones. Wipe the brush before reloading, and notice when the pool of either tone on the palette becomes polluted; if so, adjust it accordingly.

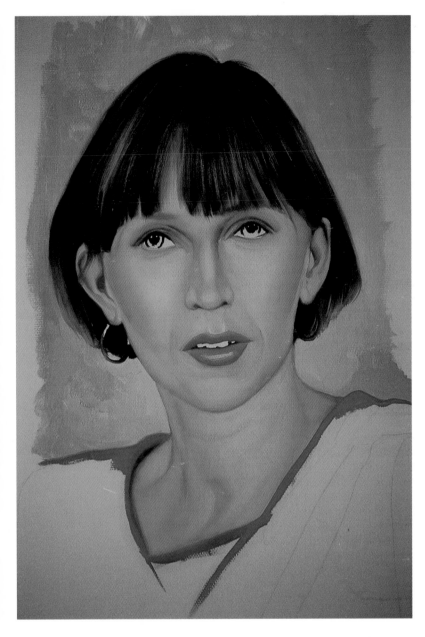

Finish the face realistically with rose white: the eyes area, the nose area, the mouth area, and the jaw area. Then begin each iris at the outer rim with blue gray.

Mix rose white (shown here in lower left of palette) and blue gray (upper left, just above the darkest rose white).

Developing the Eyes and Mouth

The eyes and mouth are continued here together because the whites of the eyes involve the same yellow gray tones as the teeth.

MIXING
Mix gray tones, including blue gray and yellow gray, by adding a little white to the yellow black and yellow brown side of the palette.

LOADING THE BRUSH
Use the no. 1 round brush, shaped with a sharp point, for working in the confined areas of the eyes.

STROKING ON THE PAINT
Fill in the top half of each iris with blue gray. This tone represents the shadow cast by the upper lid. Begin the whites of the eyes as well as the teeth using yellow gray, but leave the lightest area clear in each "eye-white triangle" and each tooth. These highlights will be filled in with light yellow gray, the almost white tone that will follow in the next step.

BLENDING
These tones should take in the outer edge of the features they surround and blend slightly with the foreign tones beyond. The iris area blends slightly with the outer rim of the iris already present, and with the original yellow black tone of the lash lines. The outer edge of each tooth blends with the wet tones in the mouth or on the lips and gum where they meet.

CLEANING UP
Wipe the brush as usual. Also be sure to correct errors such as the spilling of red tone from the mouth onto the teeth.

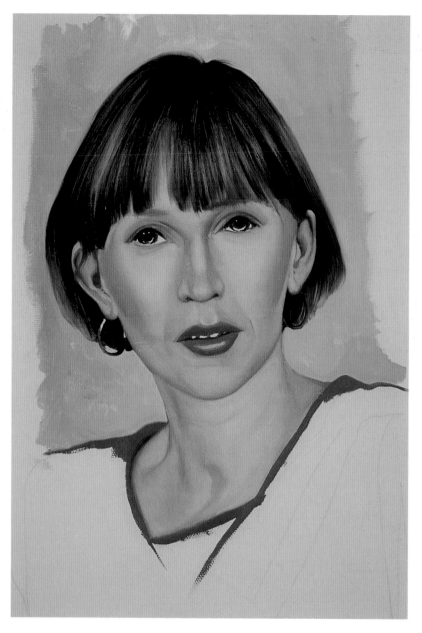

Continue the irises, filling in their top halves where they are in shadow. Begin the whites of the eyes as well as the teeth.

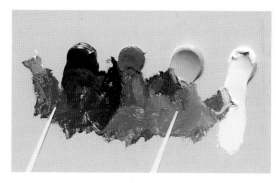

Mix blue gray (left) and yellow gray.

Finishing the Eyes and Mouth

On page 93 the whites of the eyes and the teeth looked odd and not so very white. That was all right because the lighter gray tones we will now add will "polish" these areas to a realistic finish.

MIXING

Tint blue gray with white to mix light blue gray (for blue eyes). Also tint yellow gray with white to mix light yellow gray, which will be used for the whites of the eyes and the teeth. The yellow cast of this tone buffers against the overwhelming amount of red in the mouth area.

LOADING THE BRUSH

Shape the no. 1 round brush into a point.

STROKING ON THE PAINT

Finish the iris realistically with light blue gray by stroking it in a crescent-shaped area along its lower half. Then finish the whites of the eyes by introducing light yellow gray into each triangle at the eye corners, on the tip of the sharply pointed brush. Stroke in this tone with care, and concentrate its greatest effect at the lower lids, especially where they meet the irises.

Introduce light yellow gray into the lightest spot on each tooth.

BLENDING

Blend the lighter lower half of each iris with the darker upper portion. Further blend the light yellow gray tone in each eye triangle with the darker yellow gray around the edges, for the impression of round eyeballs. Then carefully blend each tooth at its lightest spot to a nearly white glow.

CLEANING UP

Wipe the brush regularly, and watch for errors and blemishes.

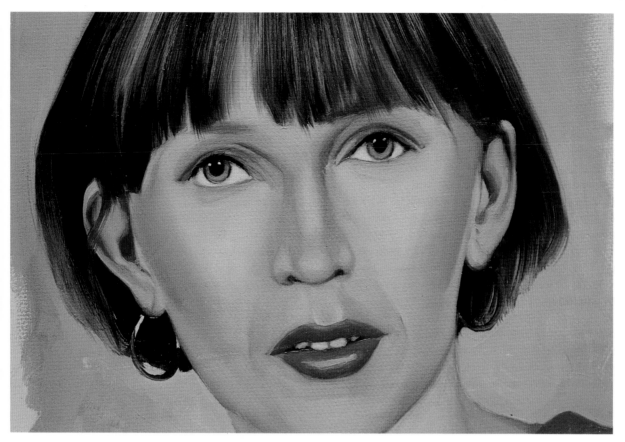

Finish the irises realistically as well as the whites of the eyes and the teeth.

Mix light blue gray (left) and light yellow gray.

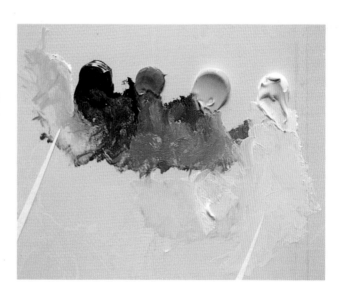

Completing the Portrait

Now look at your portrait as a whole without looking at any specific area. Stand back and take it all in at a glance. See whether anything looks strange.

The cheekbones in this portrait needed softening, so I slightly blended the dimple area below each cheek. Also, the temples seemed to lean out too far at the upper portion of the ears where they attach to the temple area. I solved this by filling in that area with a little hair tone, thus narrowing the face slightly.

The point is that what might have seemed to require major repainting to slim the face was achieved in just a few strokes. So if you find something wrong with your painting, don't be discouraged. Before jumping in to fix it, make sure you have studied the problem long enough to know what really caused the aberration.

MIXING
Mix and use whatever tones you have used before to make adjustments to improve the likeness, and to complete the clothing.

LOADING THE BRUSH
Use brush sizes as needed.

STROKING ON THE PAINT
Correct the likeness as needed and finish the clothes and background.

Use all previous tones as necessary.

BLENDING
Blend tones and balance yellow shadows and reddish light areas.

CLEANING UP
Check for errors and blemishes. The more complete a portrait, the more apparent the flaws.

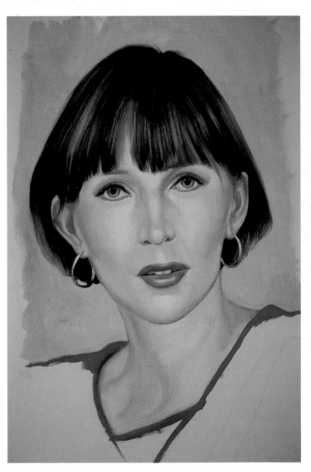

(Above) Correct the likeness if it is not quite accurate. Also add a little darkening along the lower lids with the yellow gray. This should resemble a hint of lower eyelashes and ride the crest of the lower lids, but not up against the eyeballs.

(Right) Finish the portrait by stroking in the clothing, using a darker red in the shadows and lightening it with white and a little yellow where the light strikes it. Adding the clothing colors makes the skin tones appear lighter by contrast; think about such effects when you plan lighter or darker background and clothing tones. In this case the effect on the young woman's complexion is pleasing.

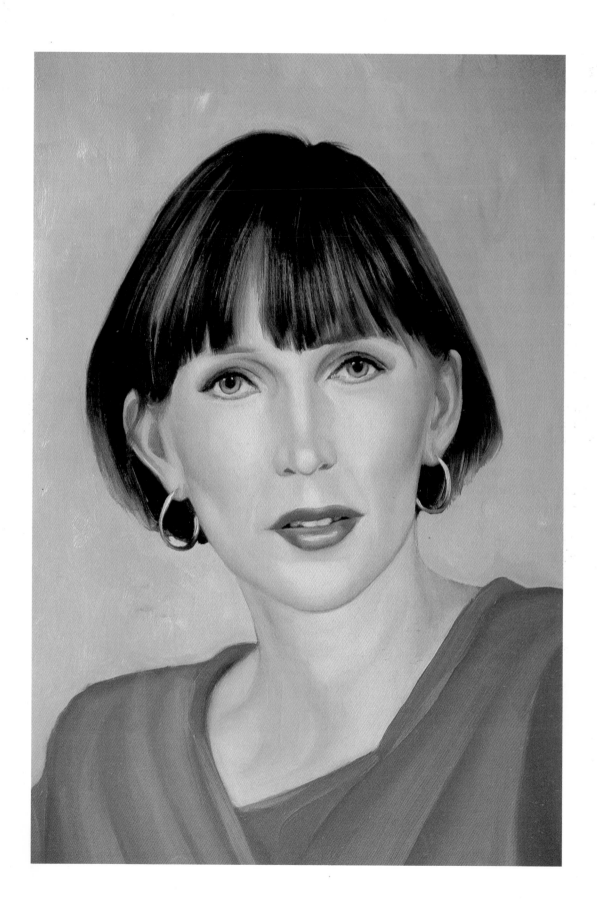

Skill Level Three:
Portrait of a Man

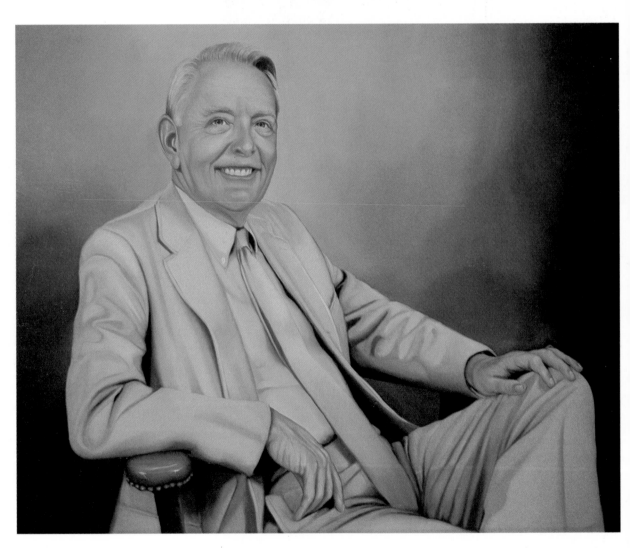

The following demonstration is an example of a complete portrait that goes beyond the head and shoulders of the previous demonstration to include a suit, a shirt, and a tie. Here is also shown the rendering of an older face as well as a pair of hands. Just as in Skill Level Two, all parts of the face and hands are painted in one cycle through the tone sequence for a light complexion, from dark to light. The clothing is painted separately because the tones are quite dissimilar from skin tones. Clothing can be of any color, and its rendering also cycles through varieties of dark to light of that color.

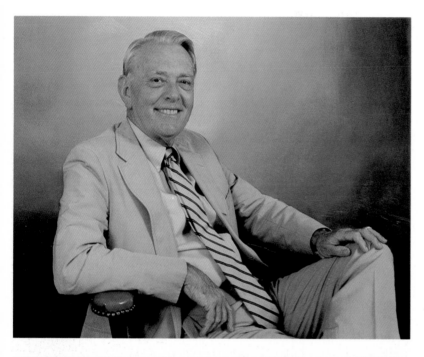

Here is the photo that I used for the demonstration in Skill Level Three.

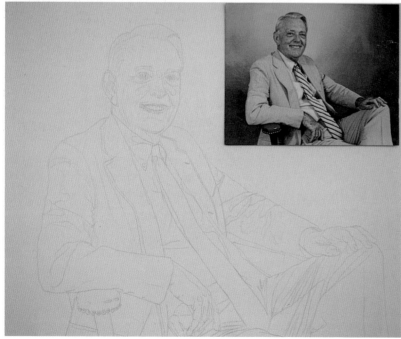

The photo is attached to the canvas for easy reference.

Setting Up and Beginning the Darks

As always, before painting, make a palette in some convenient place on your canvas by attaching two strips of package tape. Choose a spot that is accessible but where you won't get your painting hand into it. Attach the photograph to the canvas also, so that your painting hand and arm do not block your view of it and no glare reflects off it.

You are ready to squeeze out a little of each of the four colors in order—from left to right, blue, red, yellow, and white—and begin.

MIXING

Mix yellow black from blue and red with a little yellow, so that the tone appears neither too purple nor too green.

LOADING THE BRUSH

Use the no. 1 or no. 3 round brush within the confines of the eye area and the no. 6 flat brush along the edges of the hands.

STROKING ON THE PAINT

In this demonstration, as in the preceding ones, we find the darkest point in the portrait and begin painting there—that is, the pupils and lash lines. As we did in Skill Level Two, we also go beyond the eyes area and find other places either in or around the face that have the same tone, yellow black. This time the tone in the mouth corners is dark enough to be stroked in during this initial step.

In this particular portrait, yellow black does not appear in the dark shadows of the hair alongside the face or behind the ears. These places must wait until later. However, we are including hands. Therefore, use the no. 6 flat brush to stroke in the indicated area. Leave the crisp edge to partially outline the hands, replacing the pencil lines there. Because we intend to surround the hands and head with wet paint before beginning them directly, search out other yellow black shadows in the immediate vicinity of the hands (none remain around the head).

BLENDING

No blending is required at this time because no other tones are present on the canvas.

CLEANING UP

As always, before reloading the brush with the same or a different tone, wipe it on a paper towel to straighten the hair and remove excess paint.

The four basic colors—blue, red, yellow, and white—with yellow black mixed.

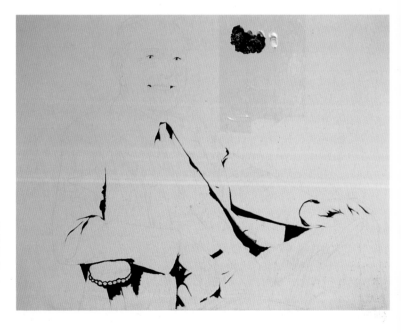

An overall view showing how all the darkest shadows of this portrait were begun simultaneously across the canvas.

A close-up view of the face. Begin the pupils, the lash lines, and the interior mouth corners.

A close-up view of the hand on the left. Begin the hand by stroking in the darkest shadows there.

A close-up view of the hand on the knee. Begin this hand also by stroking in the darkest shadows there.

Surrounding the Skin Tones with Background Color

In this step we prepare a wet canvas area to surround the outline of the head. Here it includes some of the coat, shirt, and tie as well as background tone. At this more advanced level, we also promptly proceed to stroke in the darkest tones within the face and head.

MIXING
Mix yellow brown, red brown, and other tones of the background and clothing to match those in the original photograph or to suit your taste.

LOADING THE BRUSH
Use the no. 6 flat brush for the large areas of the background and clothing.

STROKING ON THE PAINT
With yellow brown, extend the lash lines into the eye corners and begin the upper lid lines. Indicate the general shape and location of the eyebrows.

Begin the nostril interiors and the deep creases of the ear.

With red brown, continue the interior mouth corners, connecting them along the inside edge of the upper lip. Stroke whichever tone is appropriate for the background and clothing all around the head, neck, and hands, and begin the hair shadows. Though the clothing in the vicinity of these areas is just begun, try to paint as realistically as possible now to save yourself work later.

BLENDING
Blending is needed where yellow black and yellow brown meet, or where background meets clothing. Otherwise there are no secondary tones on the canvas with which to blend.

CLEANING UP
Wipe the brush before reloading and changing tone.

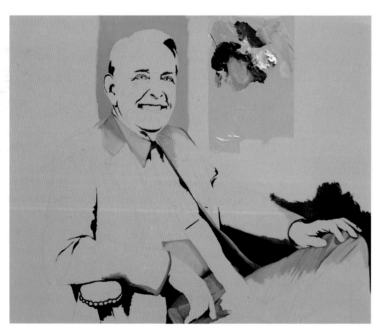

This overall view clearly shows our objective of surrounding the head and hands with wet paint, regardless of whether it represents clothing or background. Several colors are used at once to achieve this.

Use yellow brown and other tones for the background and clothing.

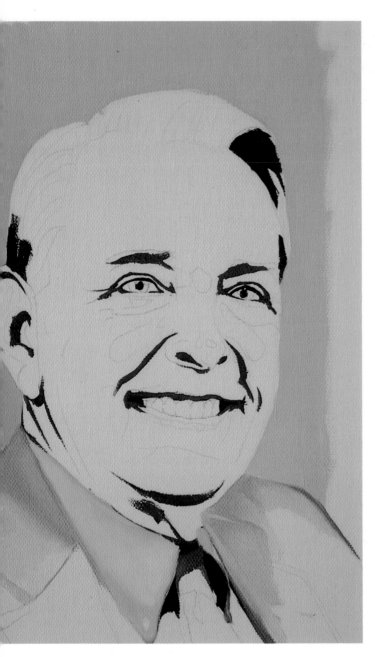

Complete the upper lash lines and begin the upper lid lines. Begin the nose area at the nostril interiors, and start the darkest shadows on the ear. Begin the hair shadows, neck, both hands, background, and clothing beyond the jawline. Continue the mouth from the interior mouth corners.

A close-up view of the hand on the left surrounded with wet paint.

A close-up view of the hand on the knee, also surrounded with wet paint.

Developing the Face and Hands

Yellow brown gives structure to the face and hands in this portrait, but there are not nearly as many yellow black areas as in the earlier portraits. This means that yellow brown does not act as a buffer zone against dark shadows as much as before, but it does buffer against the clothing and background tones at the outline of the head and hands.

MIXING

Mix yellow brown from yellow black by adding yellow orange (more yellow than red). Our subject is not surrounded by as much yellow black as in the preceding painting, and it appears that we should use a lighter version of yellow brown with less blue, almost cream orange.

LOADING THE BRUSH

Continue to use the no. 1 or no. 3 round brush within the face and the no. 6 flat brush in the larger areas of the hair, background, and clothing.

STROKING ON THE PAINT

Continue with yellow brown and begin the jaw, working around the ear, behind and around the neck along the collar. Continue along the jaw, around and up along the side of the face to the temple, letting the tone fade into the hair there. Begin hairlike strokes at the temples and continue with lighter and darker hair layers along the edge of the head, letting it blend slightly with the background.

By now the hands as well as the head have been sharply outlined with wet paint. Stroke in a buffer of yellow brown shadow tone along their outline, and very slightly blend it with the wet paint beyond. Pull some of this yellow brown tone deeper into the hands and where the fingers bend at the joints, to indicate the beginnings of creases in the skin there.

BLENDING

Blending becomes necessary now where various tones meet, and especially where the outer edges of the head and hands meet the background and clothing.

CLEANING UP

Cleaning up follows the usual routine.

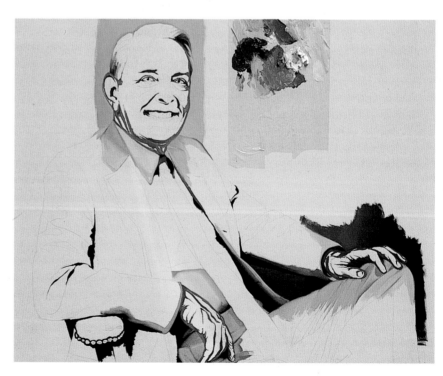

By this point an inner edge has been stroked around the head and hands.

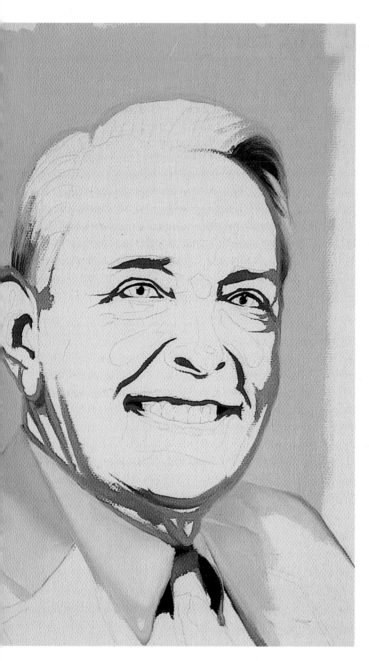

Continue with yellow brown on the jaw, ear, and edge of the neck. Begin hairlike strokes at the edges of the head—particularly, in this case, at the right temple—and continue with lighter and darker hair layers.

A close-up view of both hands with the dark shadows stroked in, outlining each hand individually.

Surrounding the Light Areas

In this step cream orange takes over from yellow brown, surrounding the light areas. These can be as small as an earlobe or a crest along a crease in a finger—or as large as the forehead or cheeks.

MIXING

Mix cream orange from yellow brown by adding more yellowish orange and a little white. Also mix rose orange for the mouth, by adding more reddish orange and a little white to red brown.

LOADING THE BRUSH

Continue with the round brushes, shaped either flat or with a point.

STROKING ON THE PAINT

Stroke on cream orange next, which takes over on the canvas from yellow brown. The tone in effect flows through the creases and folds of the skin and down into the valleys, thus surrounding areas of canvas left clear for the skin's higher areas, which will be painted later with a lighter tone. Complete the lash and lid lines and begin the eyebrows, remembering to surround the lighter areas there. Continue with the underside of the nose and then the cheek lines around the mouth corners and around the cheekbones.

The many intricate details of the fingers and hands—especially the folds of skin at the joints—are further covered with cream orange, which blends with the yellow brown buffer from before. Fine, intricate shading along creases, and subtle surfaces of small areas such as the knuckles, challenge your brush handling skills. Outline the individual fingers, pulling the shadows deep into the hand. Pools of canvas should remain unpainted, showing the light areas still to be filled in.

Now switch to rose orange to paint the lips. Leave a clear area for a lighter tone to follow at the convex surface of the lower lip.

BLENDING

Accurate shape is dependent on skilled blending, which becomes more extensive now and occurs wherever cream orange touches along the yellow brown outline. All along the outline of the hands, the new tones must touch and blend slightly with those beyond. This avoids an unnatural cut-and-pasted look.

CLEANING UP

Take more notice now of cleaning up the area before continuing. Don't leave strokes unblended, and wipe the brush carefully.

Use cream orange to complete the lash and lid lines and begin the eyebrows. Continue with the underside of the nose, then the cheek lines. Begin the lips and gums with rose orange.

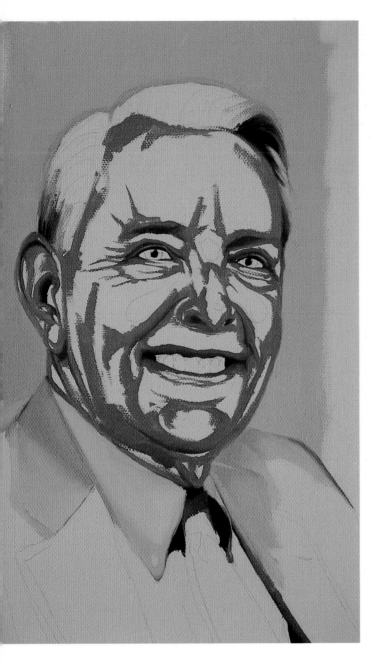

Continue with the arms and hands.

Connecting the Shadow Tones

The emphasis throughout this step is to connect islands of shadow tones into a support structure for the face and hands, still leaving the lightest areas clear to be finished with rose white in the next step.

MIXING

As you remember, cream white is cream orange with more white and a little more yellow.

LOADING THE BRUSH

Use either the round or flat brushes as needed.

STROKING ON THE PAINT

Stroke cream white into the eyes area, the nose area, the skin tone around the lips, the jaw area, and the hands. Continue filling in the ear with cream white also, surrounding the lightest points on the crests of its folds.

This is also an opportunity to block in hair color as an undertone along the hairline across the forehead. Further improve the hair by stroking in lighter strands from the back of the head and along the hair path. Leave areas clear where the hair is very light.

BLENDING

Blending is now the major part of the stroking procedure, so pay close attention to realistic shaping. Complexion is still a secondary consideration until we introduce rose white in the next step.

CLEANING UP

Before wiping the brush and going ahead to the next step, make sure any blemishes and errors are corrected. As the canvas becomes more saturated with paint, the potential for error becomes greater.

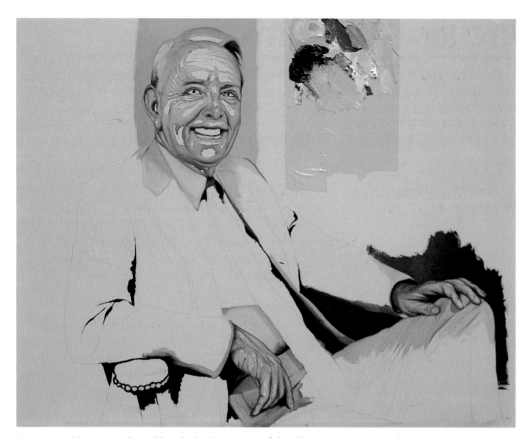

Use cream white to complete all but the brightest parts of the skin in the eyes area and the nose area. Continue the skin tone around the lips. Then complete the jaw and connect the islands of shadow. Prepare the hairline at the temples and across the forehead, continuing with lighter and darker hair layers.

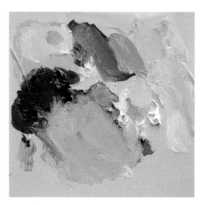

A dark cream white appears in the lower half of this palette.

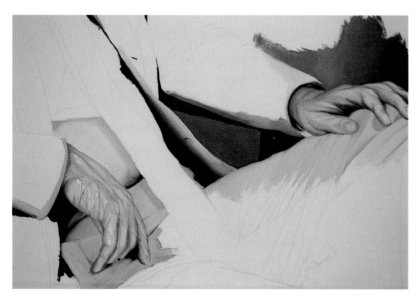

Also use cream white to complete the hands, except for their lightest highlights.

Refining Shape and Complexion

This subject has a slightly darker complexion than the child and young woman in the earlier demonstrations. We will therefore use a darker version of cream orange in this portrait. We will also use a darker rose white at first and then follow it with the usual rose white tone. This personalized color scheme, however, is still in the general family of light complexions requiring yellowish shadow tones and pinkish light tones.

MIXING
Mix a lighter and darker version of rose white, as well as rose orange.

LOADING THE BRUSH
Use brush sizes as needed.

STROKING ON THE PAINT
Rose white will complete the unpainted areas of the face, neck, and hands. Use rose white to finish the face realistically: the eyes area, nose area, mouth area, and jaw area. (You may want to refer back to earlier demonstrations and to pages 26-27, which show the blending of rose white with contrasting yellower tones.)

BLENDING
Blending is very important in this step to achieve a realistic shape and true complexion. Striving to perfect the complexion also affects the true likeness for better or worse. This is because the illusion of realistic shape on a flat canvas is created from light and dark variations of different colors placed together accurately and blended with care. Altering the complexion to improve it can alter the shape unless you are careful.

CLEANING UP
Wipe the brush before reloading and avoid mixing of the pools of cream or rose tones on the palette.

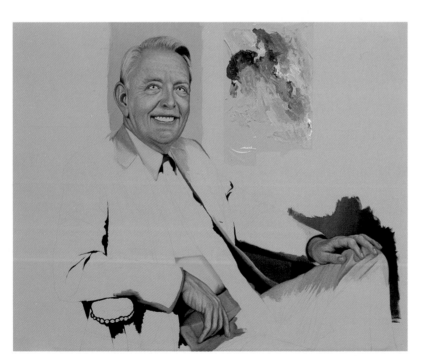

Here the hands and face have been finished with rose white and other tones.

Mix dark rose orange (top) for the lips and gums, as well as rose white (center), and dark rose white (right).

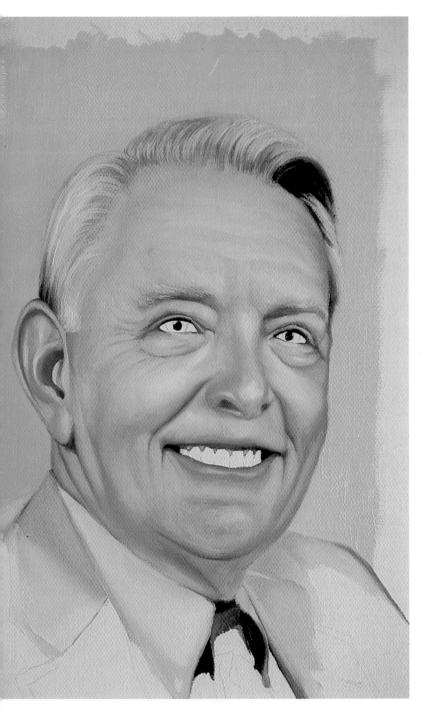

Finish the face realistically: the eyes area, the nose area, the mouth area, and the jaw area.

Finish both hands.

Developing the Eyes and Teeth

At this level of painting, the whites of the eyes and the teeth are usually painted together since they have the same yellow gray tones. In preparation, however, the irises should be painted first, and also the interior mouth area if it is visible—or at least the mouth corners and gums.

MIXING

Mix blue gray by adding a little white and blue to the yellow black side of your palette, and mix yellow gray by adding white and very little blue to the yellow brown side. You will also need light blue gray and light yellow gray, mixed by adding white to blue gray and yellow gray.

LOADING THE BRUSH

Use the no. 1 round brush shaped with a sharp point for working in the confined areas of the eyes.

STROKING ON THE PAINT

Begin the iris at the outer rim with blue gray. Then fill in the top half of each iris, where it is in the shadow cast by the upper lid.

Begin the whites of the eyes as well as the teeth using yellow gray, but leave a point clear in each "eye-white triangle" and tooth for a light yellow gray (almost white) tone to follow in the next step.

Now finish each iris realistically with light blue gray by stoking it in a crescent-shaped area along the lower half. Finish the whites of the eyes by introducing light yellow gray into each triangle at the eye corners, on the tip of your sharply pointed no. 1 brush. Rub this tone in there with care, concentrating its greatest effect where each lower lid meets the iris. Also paint the tiny highlights in the eyes, being careful to make them match precisely.

Stroke light yellow gray into each tooth, and finish it by blending it with the darker yellow gray from before.

BLENDING

These tones should take in the outer edge of the features they surround and blend slightly with the foreign tones beyond. The iris area blends slightly with the outer rim of the iris already present, and with the original yellow black tone of the pupils and lash lines. The outer edge of each tooth blends with the wet tones in the mouth or on the lips and gum where they meet—but be careful to blend delicately outward, so that the teeth do not get pink! Blending of the light lower half moon of each iris should occur where it meets the darker upper portion for a seamless transition of tone. Further blending occurs in each eye triangle so that the whites of the eyes give us the impression of the roundness of the eyeballs. Continue blending—in effect, polishing each tooth at its lightest spot—to an appropriate white glow.

CLEANING UP

Wipe the brush as usual, but also correct errors such as the spilling of red tones from the mouth onto the teeth.

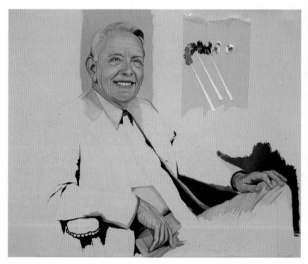

An overview of the portrait so far, with the eyes and teeth begun.

A slightly darker yellow gray than usual (left) is used for the edges of the teeth and whites of eyes. Yellow black (middle) is used to outline the irises. A dark red brown (right) is used for rewetting the interior corners of the mouth.

The right arrow indicates a blue gray (not light blue gray) used to begin the upper half of each iris on either side of the pupil, under the shadow of the upper lid. Light yellow gray (left) is used for the whites of the eyes and the darker teeth in the rear of the mouth, but a light yellow gray that appears almost white (middle) is needed to finish the whites and the teeth realistically.

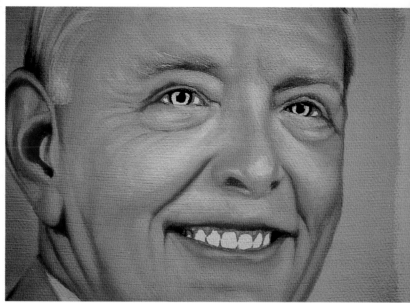

Begin each iris at the outer rim with blue gray. Begin the whites of the eyes and the teeth with yellow gray.

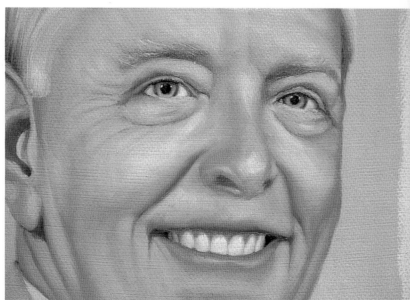

Finish the irises realistically with light blue gray, as in earlier demonstrations. Finish the whites of the eyes, as well as the teeth, with a light yellow gray that appears almost white.

Developing the Clothing and Background

Clothing is fun to do and more forgiving than the face or hands because the creases and folds can be followed more easily. The approach remains the same: Seek out the darkest tones in the shadows and progress gradually lighter. Remember that because the head is the most important part of a portrait, the most crucial part of the background is the part that surrounds the head.

Fabrics come in any color, so matching the colors in your photograph is less important here. To achieve realism in fabric to the point where it can be recognized as wool, satin, silk, corduroy, or some other variety, you must apply contrasting tones and blend them to definite texture. This is not physical texture such as brush marks left in the paint, but the illusion of texture through the interplay of bright or dull highlights and darker tones. This is similar to the way we did the hair but with far more sophistication and control of wet tones applied over wet undertones. There are books that cover fabric textures in detail; for now, let the clothing at least appear naturally realistic.

MIXING
Mix and use whatever tones you have been using for the clothing and background. Here I selected a yellow black for the dark creases in the suit and a blue tone for the shirt. As you move from shadows to middle tones, mix lighter versions of the same colors. This suit happens to need a pale cream orange tone; it has more blue and white than the cream orange tones we have used for skin, so that we must, in effect, introduce gray into orange.

LOADING THE BRUSH
Use the no. 3 round brush for the deeper creases in the clothes and the no. 6 flat where the creases begin to unfold.

STROKING ON THE PAINT
The rest of the subject, in effect the clothing, must now be surrounded with wet background paint to leave a sharp edge along the pencil outline it replaces. It is also time to render the deepest and darkest creases in the pants and jacket. The arm of the chair is also further developed in its darkest shadows. The shirt receives blue tones, both dark and light, to indicate folds.

Begin the clothing by stroking pale cream orange into the suit. Start from its outline against the wet colors of background, shirt, and hands, and work inward along a path that follows any creases, folds, and seams found there. Remember that the outline of the clothes should blend slightly with the background tones beyond to avoid an unnatural cut-and-pasted look.

Work along the darkest creases of the clothes first, and then along lighter ones, progressively isolating the lightest areas to be finished with a lighter tone in the next step. There will be a myriad of these folds in all directions, not as orderly as in the skin, but then not as critical either.

BLENDING
Blending is necessary wherever these new tones brush up against older tones already on the canvas. Just as with the skin tones earlier, blending the tones of the clothing sculpts and "unfolds" the fabric surfaces into three-dimensional shapes with a realistic color scheme.

CLEANING UP
Wipe the brush when changing tones to avoid contaminating the mixed tones on your palette. Remove brush marks and correct errors to finish the clothing to the same high standard of realistic painting as the rest of the portrait.

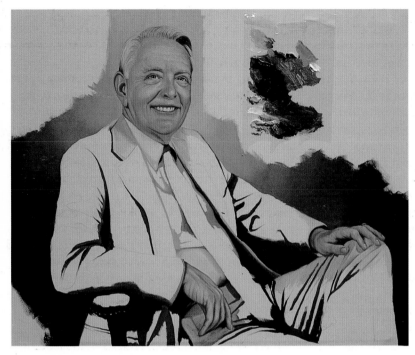

The darkest creases have been added to the clothing with yellow black and blue.

This somewhat pale cream orange is the main color for the suit.

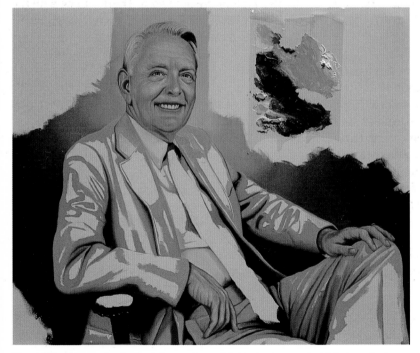

The clothing is now developing into a pattern of light, shadow, and middle tone that makes its texture and wrinkles start to come to life.

Adding Finishing Touches

Once the clothing is done—that is, all the canvas below it is covered and it looks realistic—go further and try still lighter versions of the colors along some of the creases, to see whether this won't further dramatize the contrast against the shadows in the creases. If so, this will further enhance the depth and three-dimensional appearance of the clothing, or of anything else for that matter. You do of course reach a point where further refinement does not improve anything, so test in a small area first.

MIXING

Add more white to the pale cream orange tone used before, to complete the suit. You will also need a light blue to complete the shirt, a cream yellow to finish the tie, and even a little orange in its shadow so that they do not turn green against the blue of the shirt. (If you are using your own photo, choose similarly appropriate tones.)

LOADING THE BRUSH

Again, use whatever brush and shape is appropriate.

STROKING ON THE PAINT

Complete all the creases and ridges of the suit until all the canvas below is covered. Take note of the degree to which the fabric's pleats and creases are sharply defined or obscure. With a light blue tone, do the same for the shirt, preserving the dark shadow where the shirt abruptly disappears under the jacket. The tone of the tie in its creases at the knot and along its edges should be quite orange even though we are painting a yellow tie. The presence of red will ensure that the lighter yellow tones to follow do not give a green appearance when brushing up against the deep blue of the shadows in the shirt. The rest of the tie starts out shiny and bright with a white and yellow tone and steadily turns darker as it moves downward.

BLENDING

Blending becomes all-important now to "melt" the light and dark tones together wherever they meet. This gives the impression of realistic shape, not only to identify the clothing as either a suit, a shirt, or a tie, but to convey the impression of the human form inside.

Complete the background with stroke textures according to your taste. As long as the outer edge of the subject is blended very slightly with the background, I have no rules for the plain background where no objects are involved. You can suit your creative taste. I like using a tone other than those used in the face, so you see me use blue and aqua tones often.

Make adjustments and improvements as needed. Try to visualize, with the help of your photograph, just where the light is coming from that illuminates surfaces in the clothing and across the rest of the portrait.

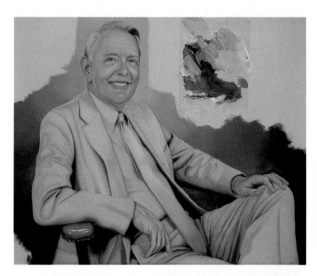

By now the clothing has been finished.

As indicated by the arrow, a lighter version of the preceding tone is achieved by adding more white.

A portrait is probably never finished in the eye of the artist but only reaches a state of acceptability—a point when it is time to stop before it might become worse. But it is important to keep your standards high, both for your own artistic development and so that a portrait that satisfies you is already well beyond the expectations of the client.

Finally, I use Damar varnish in either brush-on or spray form to preserve the portrait. Choose an artist's quality varnish that does not yellow over time and is removable for restoration. The varnish seals out dust particles so that they can be easily wiped off with a moist towel. I prefer a varnish with a glossy finish because it brings out the luster of colors as if they were still wet. Usually I deliver a painting unvarnished to the client and return there several times two or more months later to varnish it. Thickly painted canvases may require six months to a year before varnishing.

A removable varnish can be replaced by an expert in 20 years or so, but this can be costly. Thanks to the colorfastness of modern paints, no change should occur to the colors of your painting in a hundred years if it hangs in a clean environment, is dusted occasionally, and is out of direct sunlight.

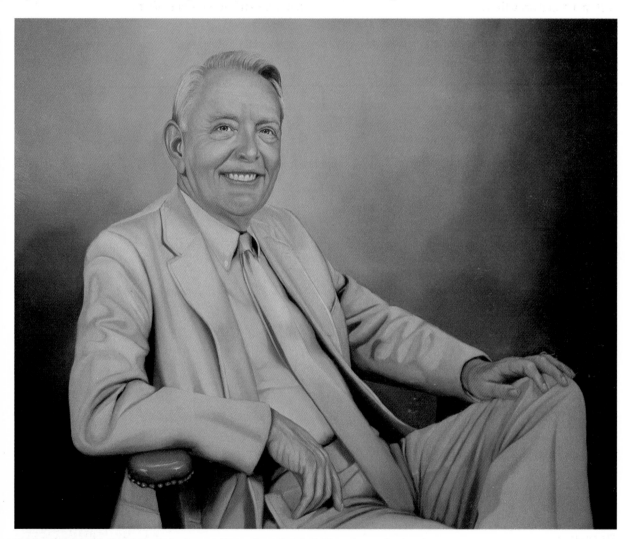

The finished portrait. A variation in background tones from dark to light creates contrast and depth, just as it does within the skin tones and clothing. This is because dark tones anywhere in the portrait appear to recede in comparison to light tones, which seem to emerge. This is the key to creating three-dimensional effects on a flat surface. Also note that the tones should vary uniformly behind the subject, not around the subject, to prevent an unacceptable halo effect.

SKILL LEVEL FOUR:
PORTRAIT OF A COUPLE

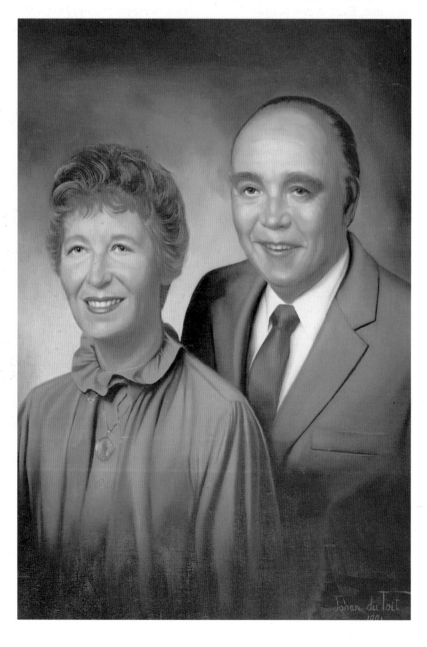

This demonstration is yet another degree more difficult than the preceding one. The approach is most similar to that used in painting the young woman in Skill Level Two, except that instead of one head, we are painting two simultaneously onto the same canvas. We will also be painting skin tones "an octave lower" because both subjects have somewhat tanned complexions. Still, the shadow tones will be predominantly yellow, while the lightest tones will be predominantly pink.

We will not paint one face and then the other, since that would create a great risk of their ending up with different skin tones. Even if two people actually do have different complexions, we still paint them together. You will recall from the discussion of color mixing that we can personalize a complexion by controlling the yellow versus red content of the dark and light tones as we proceed. For example, if one person has a redder face, you finish that face with a pinker rose white. On the other hand, if one person has a more olive or copper-toned complexion, the rose white should have more than its usual trace of cream white. You will also recall that very dark complexions have reddish shadows and yellowish light tones (instead of the yellowish shadows and rosy light tones we have seen in the light complexions illustrated in this book).

This demonstration is mostly pictorial. The text is kept general since all of it has been covered at some point during the preceding three portrait demonstrations.

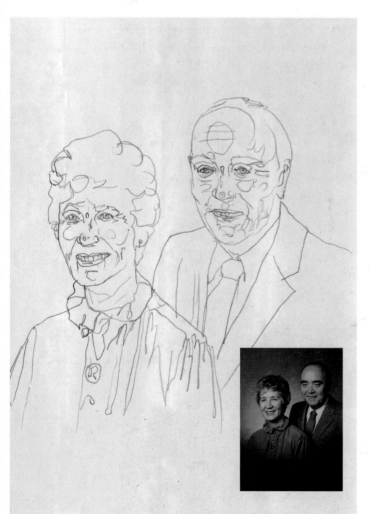

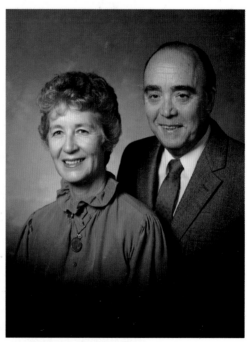

Here are the original photo and pencil drawing for the portrait in Skill Level Four.

Laying In the Darkest Tones

In this step we are beginning, as usual, with the darkest tones within the faces, and then stroking in yellow brown as a buffer between yellow black and the lighter tones to follow. We also surround the skin areas with wet paint (clothing and background colors) so that when we paint the skin tones we can blend the edges slightly.

Begin the pupils, lash lines, and nostril interiors with yellow black, as well as the few dark places in the hair. The suit around the man's shoulders is also yellow black but will receive some lighter tones later for definition. Begin the interior corners of the mouth with a little red black (just add a little red to the yellow black) to reflect the presence of blood vessels there. The blue gray background tones define the outline of the heads and give a wet tone to work with there.

The four basic colors are arranged in the usual order. Yellow black is mixed to begin the darkest places in both faces. Variations of blue gray tones begin the background immediately around the heads with a touch of yellow mixed in for a slightly green or aqua tint in places.

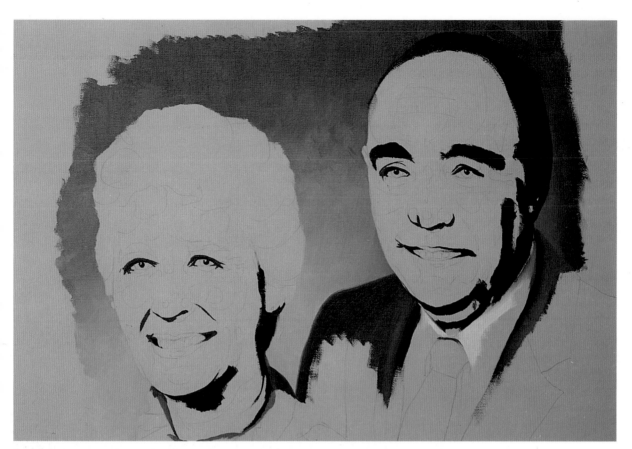

With yellow brown begin the upper lid lines and complete the lash lines. Prepare the man's hairline, which also happens to coincide with the outline of the head. It blends slightly with the background wherever they meet. Continue the inside of the mouth from the interior mouth corners, and fill in the darker shadows under both jawlines. Fill in ears (in this case, only one of the man's shows) and insulate a light area on the lobe. With a lighter yellow brown, continue with each nose outline around the tip and nostrils.

We begin the faces with a fresh palette and mix the first tone, yellow black, as the arrow on the left indicates. From this is derived yellow brown (center arrow) and then a lighter yellow brown (more yellow and a touch of white added) on the right:

Building Facial Structure

Now we start to work inward from the darkest creases and shadows, starting to define the structure of the faces with cream orange.

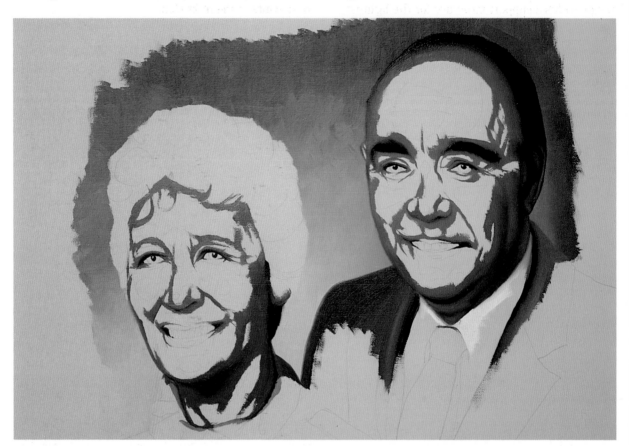

Continue with the round brushes shaped flat or pointed and stroke in the following areas in both faces.

Complete the lash and lid lines and begin the eyebrows. Continue with the outline of the nose and the cheek lines from the sides of the nose down to the mouth corners, where they connect.

Continue both jawlines along their edge from temple to temple, and allow the skin tone to blend slightly with the background tone. First work around each chin and then define the shadows on the neck and its outer edge, including the collar. Continue up from the temples across the forehead, and work the tone into the previous tones at the hairline.

As you work, blend each new tone together with those already on the canvas where they meet. Besides wiping the brush regularly, correct errors before proceeding to the next step.

Cream orange (left arrow) takes over on the canvas from yellow brown. On the palette yellow brown is tinted with the addition of more yellowish orange and a little white. A lighter version (right arrow) is needed to continue shading in the central area of the faces where they are not quite as dark.

Laying In the Lighter Tones

Here we connect islands of shadow tones in each of the faces on the canvas with a dark cream white. This provides a support structure for the lightest areas, left clear for now, which will be filled in with a very light cream white first and then finished with rose white in the next step.

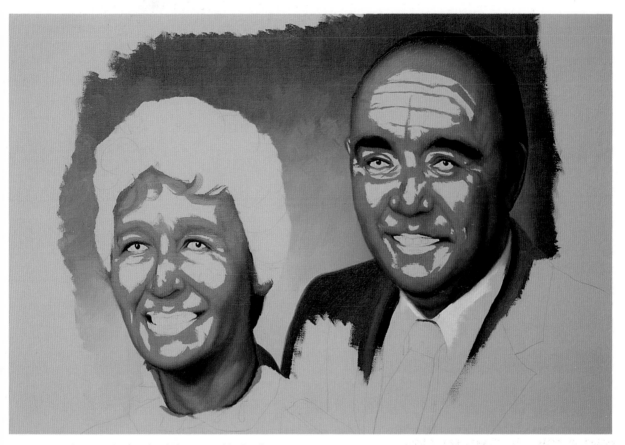

Here you see the portrait after the dark cream white has been stroked on, but before the lighter version. Use either the round or flat brushes for this step. Blending is now the major part of the stroking procedure, so pay close attention to realistic shaping. Remember that complexion is still a secondary consideration until the next step.

Mix cream white by adding white and a little yellow to cream orange. Note that this is a darker cream white than that used in earlier demonstrations because the photo shows richer, more tanned skin tones. This is an example of personalizing your colors to match your subjects' true complexions.

The left arrow indicates a slightly reddish cream white, and the right arrow shows a lighter, more yellow version.

Indicating Light Areas

By stroking a lighter and darker rose white into the palest areas of
the skin, we refine shape and complexion in both faces at once.

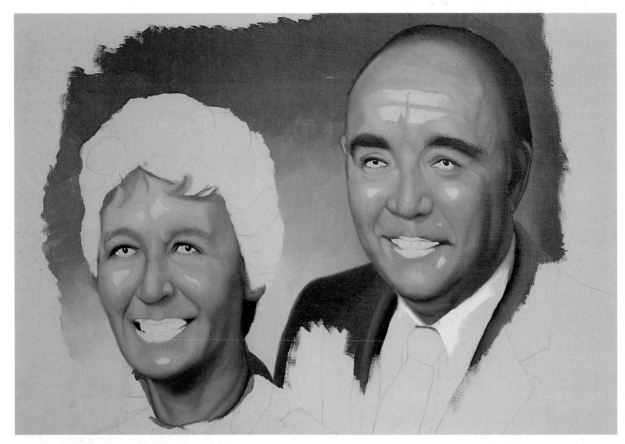

Use whatever brush sizes you need to stroke rose white into all
unpainted areas in the face and neck. The slightly darker
complexions of this couple will require two stages of rose white to
fine-tune the shape, likeness, and complexion of each face. Here
you see the portrait after both versions of rose white have been
applied. The lightest places are still left blank because the rose
whites darken considerably when blended with the dark cream
whites. I will come back later to apply pure, light rose white to
these highlights.

Mix rose white (right arrow)
with white and a little red. The
darker pink (left arrow) may be
used at the edge of the lips.

Finishing the Faces and Hair

These close-up views of the two faces show the finished skin surfaces, as well as the completion of the eyes, mouths, and teeth. You can also see the rendering of the woman's hair.

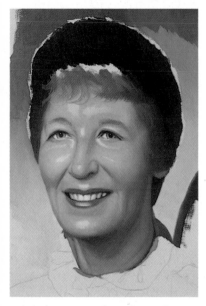

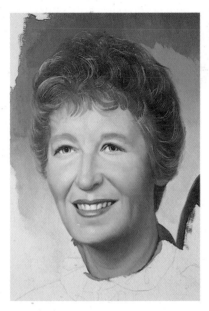

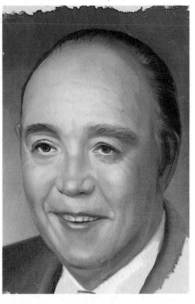

Here is the woman's face about to be retouched with the lighter rose white. As you can see, it has been stroked onto the skin but not yet blended. The undertones of the hair are also now in place.

The woman's head, completed.

The man's head, completed.

The two bottom left arrows indicate a light and dark yellow gray with which the whites of the eyes and the teeth are begun and then finished with a little white. Because the overall effect of this portrait is darker, the yellow gray for shadowed portions of the eyes and teeth must be darker too, in order not to stand out unnaturally.

The other two bottom arrows indicate reddish tones, light or dark, used to finish the lips. The arrow on top points to dark red brown for the interior corners of the mouth.

The undertones of the hair are really dark skin tones—versions of red brown and yellow brown. In this portrait the woman's light curls are finished with the yellow gray tones used in the eyes and teeth.

Developing the Clothing and Background

These views show the gradual completion of the clothing and background.

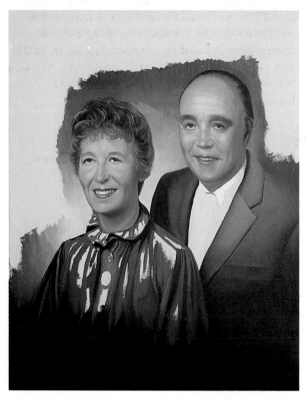

Many of the darkest creases of the clothing have now been stroked in.

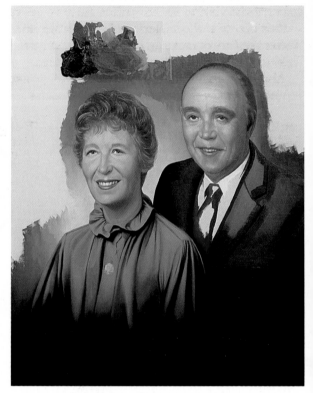

The clothing developed further.

The palette shows some of the various tones, still mixed from the basic four, used to complete the suit, tie, dress, and jewelry in this portrait, as well as the background.

The Finished Portrait

This demonstration has illustrated that it is a mistake to paint generic skin tones. Beginning painters who yield to this temptation fail to do justice to their clients' real complexions. Using lighter and darker versions of cream white and rose white will help you adjust the skin tone to the correct hue.

Also remember that when you paint two or more subjects in the same portrait, their complexions must complement each other. In this particular example, the couple's complexions were similar. But if you ever need to paint a sunburned person next to a pale one, minimize the differences in complexion rather than exaggerating them. In this way you can still suggest each individual's true skin tones and yet make the overall portrait look harmonious.

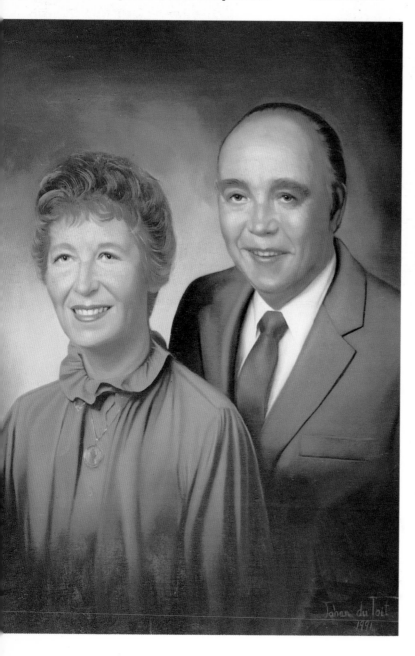

The finished portrait. Note the different textures of the woman's blouse, the man's suit, the man's tie, and the woman's gold necklace.

Index